WRIGLEY FIELD

100 STORIES FOR 100 YEARS

• DAN CAMPANA & ROB CARROLL •

INTRODUCTION BY WGN-TV'S DAN ROAN
FEATURING A SPECIAL STORY BY KERRY WOOD

Charleston London

THE
History
PRESS

Published by The History Press
Charleston, SC 29403
www.historypress.net

Front cover, top: Courtesy of Bob Horsch (www.horschgallery.com).
Front cover, bottom: Photo by Dan Campana.
Back cover, left: Courtesy of Bob Horsch (www.horschgallery.com).
Back cover, center: Courtesy of Jenkins Imaging.
Back cover, right: Courtesy of David Levenson.
Back cover, bottom: Courtesy of the National Baseball Hall of Fame Library, Cooperstown, NY.

First published 2013

Manufactured in the United States

ISBN 978.1.62619.034.4

Library of Congress CIP data applied for.

CONTENTS

Contents

Contents

PREFACE

Wrigley Field: 100 Stories for 100 Years is very simply a collection of personal stories about baseball's greatest ballpark and the relationships so many people have with it. The book is designed to offer an informal oral

Writers Dan Campana (left) and Rob Carroll became friends in 2000 and attended their first Cubs game together on May 22, 2001, when Todd Dunwoody made a surprise start in right field for Sammy Sosa. *Jenkins Imaging.*

history of what has made Wrigley such a unique part of baseball and Chicago. With millions of Cubs fans around the world, it's likely there's at least one story here that you will connect to on some level.

So, how'd they do it? In January 2013, Dan and Rob began sending out requests for interviews to many of the notable names you'll find in these pages. Beginning in March 2013, they hit the streets of Wrigleyville to talk with fans, business owners and residents who share their neighborhood with the Cubs. Many interviews were done in person or over the phone, while some stories were collected via e-mail. Every story in the book was either written by Dan or Rob or edited from a requested submission. Although the Chicago Cubs are referenced throughout the book, *Wrigley Field: 100 Stories for 100 Years* is not affiliated with the team.

ACKNOWLEDGEMENTS

This book would not have been possible without help from many, many people. In particular, we'd like to show our appreciation to the following folks who made a big difference—in their own special ways—during this project (in no particular order):

Jaime and Matt with Fox Valley Voice; John Horne with the National Baseball Hall of Fame; Paul Johnson; Matt Hanley; Kevin Gregg with the Boston Red Sox; Leni Depoister and Ray Garcia with the Chicago White Sox; Daphne Ortiz with the Wood Family Foundation; Ben Jenkins of Jenkins Imaging; Dana Rogers of Edenhurst Studio (www.edenhurststudio.com); Victoria Kent with Rockit Burger Bar; Shawn Touney with the Kane County Cougars; @HockeyBroad; Paul Ashack (www.paulashackstudios.com); Bob Horsch (www.horschgallery.com); Holly Johns (www.hollyjohnsphoto. com); Brad Hainje and Jim Misudek of the Atlanta Braves; Higgins' Tavern on Racine for the beer and parking permits; Fran Sylve; Kristen Taylor; Dennis Meinicke; Sheila Siel; Nancy Tiffen; David Levenson (www. wrigleyfieldvideo.com); Louis Barricelli with MLB Network; Rich Buhrke (www.ballhawksmovie.com); Patrick Yarbrough; Julie Hanson; Jason Zillo, Michael Margolis and Alexandra Trochanowski with the New York Yankees; Tony Andracki with Comcast Sportsnet Chicago; Kerrigan McNeill of the Fergie Jenkins Foundation; Kristen Hudak with ESPN; Mickey and Steve Cucchiaro; Dave Eanet from WGN; Dave Hoekstra; Paul Campana; www. baseball-reference.com; and everyone who liked or followed us on Facebook

and Twitter, took the time to talk with us about the book or politely declined our interview request.

As you read the names attached to these one hundred stories, be sure to know we owe them the ultimate gratitude for contributing their time in the variety of ways they did.

Dan also wants to say a special thank you to his loving family—Jen, Ryne and their little dog, Kaner—for letting him run an office from their kitchen table and for never expecting him to be anyone other than who he is.

Dan and Rob would like to recognize generous support of the project by Becky Evers, Julie Hanson, John Hanson, Mary Pacyniak, Nancy Tiffen, Diana Williams, Becca Broda, Peter Wilhelmsson, Jim Sowizrol, Jim and Laurie Strong, Grandma Strong, Joseph Zink, Mary Newton, Rob's mom, Matt Riddle, Tina Rossini, Holly Johns, Matt Junker, Justin Corbett, Sean Pierce, Thad McGlinchey, John Bayler, Ricky Hendrick, Chad Anderson and Patrick Yarbrough. Thank you so much. We couldn't have done it without you.

1

INTRODUCTION

DAN ROAN, WGN-TV SPORTS DIRECTOR

I grew up a Cubs fan in Iowa, crying from afar over the collapse of 1969, lamenting the "College of Coaches" experiment before that and wondering then—as now—when the law of averages might finally kick in for these guys. Living at a distance from Chicago, I had no exposure to Wrigley Field as a kid. But I would make up for lost time.

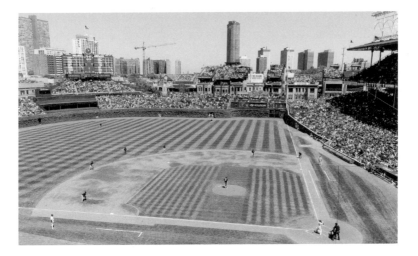

For decades, no advertisements appeared within the playing area at Wrigley Field. That began to change most noticeably in the 2000s, when ads showed up on outfield doors, on the field's tarp cover and on various spots on the famed brick walls. *Dan Campana photo.*

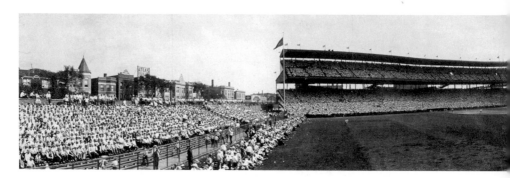

A panoramic view of the crowd at Cubs Park on July 27, 1929. *Library of Congress.*

One of my early experiences at Wrigley centered on a hard Friday night of partying, post-college, in Chicago's western suburbs. Ten of us were going to the game on Saturday afternoon, but having only a vague concept of time that morning, I showed up at the ballpark at 8:00 a.m. Owning some status as a downstate broadcaster, I wangled a press pass and spent a couple hours exploring the confines. Eventually, I sat down in the Cubs dugout, where the morning sun and the short night got the best of me. I dozed off, only to be awakened by a sharp pain in my right side. It was Bill Buckner, sticking the money end of his bat into my ribcage and telling me to get the hell out of the dugout.

Today, having covered the Cubs for over three decades for WGN-TV, Wrigley Field and I are old buddies. I was there in '84 for the first postseason games in thirty-nine years, I watched as the lights went on in '88 and I suffered through the dead years of the '90s and suffered even more in 2003. But it was the times in between that made me really appreciate the Wrigley experience.

I remember sitting in the booth with Harry Caray and Steve Stone one warm summer evening—it must have been 1991 or 1992. The baseball was not good, but the ambience was from another world—the golden cast of the setting sun, the grass and the ivy a brilliant green, a magnificent sky, Lake Michigan in the distance and a full house buzzing with anticipation of what might happen. All that right in front of me, accompanied by the Harry-and-Steve soundtrack. It really could not have been a more intoxicating moment. For me, and for millions of others, it happens time and again, summer after summer.

There's little question that Wrigley Field is as big a draw as its tenants, probably much more so. The ballpark offers hope even when the Cubs do not—how can something good not happen in a place this beautiful? Wrigley is absolutely responsible for the unfailing optimism that the Cubs have enjoyed, even thrived upon, from their massive fan base.

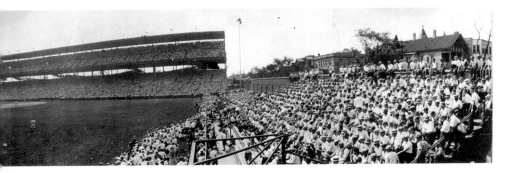

Now Wrigley Field is turning one hundred years old, and it's showing its age. The current owners, the Ricketts family, are fighting a political battle to implement a restoration plan. The mock-ups are encouraging, adding amenities to enhance the enjoyment of the fans while keeping the character of the ballpark mostly intact.

I truly hope it all works out and we are all able to enjoy Wrigley Field for many years to come. It's a magical place and one of the great contradictions in sports—a ballpark that's held more heartbreak than any other in America but one that continues to beguile, fascinate and beckon...even when Bill Buckner's jabbing you with a Louisville Slugger.

MY WRIGLEY MOMENT

KERRY WOOD, CHICAGO CUBS PITCHER, 1998–2008, 2011–12

There are many moments that make my time at Wrigley Field special—too many to list. Every summer, fans get to experience Wrigley Field for the first time. They get to see the ivy, hear the organ play, sing along with "Take Me Out to the Ballgame" and even see their first "W" flag being raised. I had a different experience—something that not many get to do. I was able to experience Wrigley Field from the center of it all—on the mound.

I will never forget my first game at Wrigley; I could barely breathe. There were more than thirty-five thousand fans that day, all of them fired up for baseball. And they already knew who I was—just a young kid from Texas. The fans supported me from my first game all the way to my last. Many will think that my favorite game would be back in 1998 when I struck out twenty batters, the different times we clinched playoff titles or even when we were only a few outs from finally reaching the World Series. For me, my most special moment at Wrigley was my last. Those same fans who supported me when I was only twenty years old were there, still with me more than fifteen seasons later.

My last day was something I will never forget. I brought my son, Justin, with me. We spent the morning of May 18, 2012, at the ballpark, watching the flags blowing out, sitting in the bleachers, touring the scoreboard, shagging balls in the outfield—it was the perfect start to this day. I savored every moment warming up in the bullpen. I walked out to the mound for the

last time. I knew it, and the fans knew it, too. This was the last time. I gave all I could to that last hitter. I wanted to end the way I started: with a strikeout and on my own terms. I knew that was all I had left. I wanted it to be in front of the fans that had given all that they had. Now it was my time to give all I had to them, to myself and to my son, who watched from the dugout.

After that last appearance, I will never forget the respect I received from the White Sox players in the other dugout, the fans and my teammates. Walking off the field, waving to them and then having Justin run out to me—it was the best moment of my career. It was special. Not many players are able to leave on their own terms, and I was able to. I will never forget it. Wrigley Field will always be my second home. I'm excited to experience more memories there, hopefully someday a championship for the most deserving fans in all of sports. Wrigley Field…there's no place quite like it.

3
WRIGLEY FIELD'S STORY

I f Wrigley Field had eyes, it might look upon itself with wonder as it turns one hundred years old.

If Wrigley could hear, the sounds of baseball would resonate and build into one collective roar of voices.

If it had the ability to speak, the Friendly Confines would most certainly draw an audience to listen to endless tales of Ruth and Mays, Banks and Santo, Butkus and Ditka, Sandberg and Dawson, Kane and Toews and McCartney and Springsteen.

Baseball's second-oldest ballpark can't see, hear or speak for itself, so it relies on its friends, visitors and neighbors to weave together a history that began quite modestly a century ago and continues today in a world far removed from the park's humble beginnings.

Wrigley Field did not begin its life with its famous name. The team that calls the park its home, the Chicago Cubs, was not its first baseball occupant either. Wrigley's birth in 1914 came as Weeghman Park on the site of a former seminary. Construction lasted all of five weeks—less time than it takes to write a book about the park's history—for $250,000, roughly half of a Major League ballplayer's minimum salary in 2013.

Weeghman served as home to the Federal League's Chicago teams, first the Federals and then the Whales. Within two years, the Federal League folded and owner Charles Weeghman purchased the Cubs. National League baseball debuted in 1916 with a Cubs win over Cincinnati on April 20.

Construction of Wrigley Field in 1914 cost $250,000 and took less than two months. This view from what would presently be the right-field bleachers shows the park's original single-deck style. *National Baseball Hall of Fame Library, Cooperstown, NY.*

Shown during construction in 1914, Wrigley's outfield featured temporary bleachers and a more straight-line shape compared to the contemporary park. Also visible is a light-colored apartment building that still sits at Waveland and Kenmore and offers rooftop access for watching the Cubs and other events. *National Baseball Hall of Fame Library, Cooperstown, NY.*

The Wrigley family, known for its chewing-gum empire, bought the team in 1920 and fittingly renamed the park Cubs Park. It remained that way until 1926, when it was dubbed Wrigley Field in honor of William Wrigley Jr.

In 1937, some of the park's most uniquely famous features first appeared: the bleachers, the ivy and the hand-operated scoreboard. The iconic scoreboard still features inning-by-inning line scores of twelve games around the majors, although baseball's expansion in the 1990s meant not every game could appear on the board. Three flagpoles atop the scoreboard reflect the current standings of the National League's three divisions.

Perhaps the scoreboard's most famous role is the raising of a flag to signify the result of the day's game—a blue "W" for a win or a white "L" for a loss. The tradition started as a way of alerting passengers at the nearby Addison train platform of whether the Cubs had won or lost.

The outfield wall sits eleven and a half feet tall with a basket extending from it. The basket was added in 1970 as a crowd-control measure during the heyday of the Bleacher Bums but is more well known for its ability to catch balls with barely enough home run distance.

With the Cubs as its main occupant, Wrigley also played host to Chicago Bears home games for half a century through 1970. The football field ran from the first-base line to the left-field bleachers, with temporary seating for fans positioned in right and center field.

Wrigley's history was forever changed in 1988 when, after a prolonged debate, the park became the last in baseball to add lights. The planned debut of night baseball at Wrigley on August 8, 1988, was short-lived as Mother Nature stepped in and forced the postponement of the game against Philadelphia. One night later, the Cubs beat the rival Mets in the first official night game.

In the twenty-five years since electricity lit up Wrigley for night games, several renovations of varying sizes have taken place. Private suites, a new press box and bleacher expansion brought the most visually striking changes to the park's look. Players would probably point to the leveling of the playing field among the significant alterations affecting game play, along with modifications to seating configurations behind home plate and near the on-field bullpens. A sizable video board, the park's largest, above the right-field wall was added prior to the 2012 season.

Wrigley welcomed concerts for the first time in 2005 when Jimmy Buffet packed Parrot Heads into the park. Bruce Springsteen, Elton John, Billy Joel, Dave Matthews and the legendary Paul McCartney have all graced

A trolley car sign informing riders it was game day at Wrigley. *National Baseball Hall of Fame Library, Cooperstown, NY.*

Wrigley's 100th, by Paul Ashack. *PaulAshackStudios.com*.

Wrigley's outfield for shows in recent years. Pearl Jam provided yet another unique concert experience in July 2013 when its show was delayed for two-plus hours and ended well after the neighborhood curfew.

Although minor league and prep baseball games and professional soccer, as well as the return of football in 2010 for a Big Ten battle between Northwestern and Illinois, have taken the field at Wrigley over the years, the park had never been as transformed as it was for the 2009 Winter Classic hockey game between the Chicago Blackhawks and Detroit Red Wings.

The winds of change blow strongly heading into Wrigley's 100th year, as the park sits on the verge of a massive renovation destined to cost ownership hundreds of millions of dollars. Video screens will be perched behind the bleachers, while team and player facilities are due for what many say are long-overdue makeovers. The Wrigleyville neighborhood, which has grown into a destination all its own, also expects to see changes as the Cubs renovate property along Clark Street long used as parking lots.

While the 2013 season ranks as unremarkable on the field, it bears significance as perhaps the last played in the Wrigley Field known to so many through photos, TV and their own memories of the Friendly Confines. No matter how the park changes physically, its spirit and air of history will remain unaltered in the minds of those who know it best.

4

THERE'S NO ME WITHOUT WRIGLEY

DAN CAMPANA

If not for Wrigley Field, you wouldn't be holding this book. "Of course," is what you're thinking, but it's not for the obvious reason.

My parents met in Wrigley's famed bleachers in the 1970s as Catholic high schoolers, one of the countless number of relationships started inside the Friendly Confines. Friends and a common interest in the Cubs certainly helped put them in the right place at the right time, but it didn't hurt that my late grandfather, Bernard Campana, worked as a high-ranking security official at Wrigley for years. His role gave my dad the only excuse he needed to be at the park so often.

My other grandfather, Michael Benker, spent his time on the fan side of Wrigley's brick walls for Bears and Cubs games for many years. In the process, he and my grandmother Virginia raised seven children. Each of them can cite some Cubs memory from their youth. Several of my aunts and uncles have, in turn, raised their own kids with the Cubs and Wrigley.

Now in my mid-thirties, my Wrigley stories cover many sunburns, batting-practice baseballs, big crowds, pathetic crowds, hangover-inducing afternoons and, amazingly, seeing the Cubs clinch a spot in the playoffs twice. Each and every one of those experiences was made memorable because of the family or friends who shared the day or night with me.

Still, nothing can top September 18, 2008, when I got to introduce my son, Ryne, to Wrigley with my wife and my dad right there with us. On the verge of winning—GASP!—their second consecutive division title, the Cubs played flat

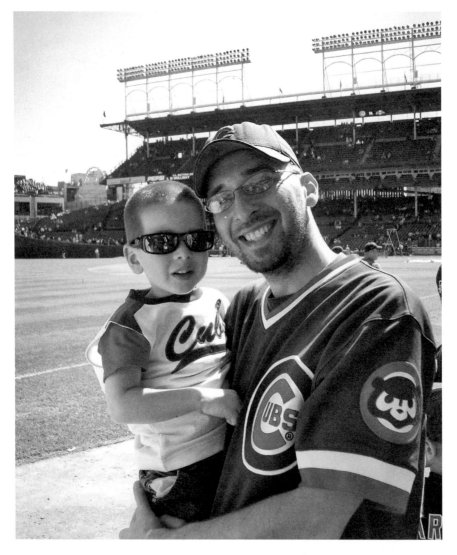

Dan and his wife, Jen, used a best-of-seven coin-flipping showdown to determine the spelling of Ryne's name. Dan won in a sweep. The name is a tribute to Dan's favorite Cub, Ryne Sandberg. *Campana family photo*.

Opposite: Dan and his son, Ryne, check out batting practice at Ryne's first game at Wrigley in September 2008. *Campana family photo*.

all afternoon. Ryne, not quite four years old at the time, had seen enough Cubs games on TV to recognize a clunker when he saw one. In person, though, it had to be a bummer for him. That all changed in a heartbeat.

With two on in the bottom of the ninth, Geovany Soto drove the first pitch he saw into the left-field bleachers to tie the game and shock the Brewers. Ryne had been sitting on my lap but immediately went skyward—safely, of course—with the instinctual jump that follows a no-doubter like Soto's shot. The Cubs finished things off with a walk-off win in extra innings, and we, as a family, hit for the cycle that day as the fourth generation of Campanas made his connection to Wrigley.

That's what Wrigley is all about. Its history is inherent to the world yet extremely personal to each fan. It's as familiar as a relative's house on Christmas Eve. It's a family reunion held eighty-one times each season. It welcomes you back year after year with the promise of a three-hour (or more) escape from reality every time you cross its threshold.

So much changes in our lives as time marches on that there isn't much you can count on for comfort—and, boy I've tried to cling on to some things at points in my life. Fortunately, family has always been a constant for me. In its own way, so has Wrigley.

CHECK YOUR TICKET

ROB CARROLL

Finally, Kerry Wood was going to come back from the disabled list after missing all of the 1999 season and the beginning of the 2000 season. And my cousin Dave had an extra ticket to the midweek game against Houston.

It also was finals week at Western Illinois University, where I was about to take my last exam before the end of the year. I was confident I knew the material on the exam, which was for some broadcasting class I had cruised through most of the year. There was enough time to finish the test and make the drive back to central Illinois to meet Dave.

Of course, it wasn't that easy. The test took a little longer than expected, and on top of that, I was asked to pick up Dave's friend Paul. I finished the exam the best I could, made the two-hour drive to my hometown of Lacon to get Paul and then another half-hour drive to get to Dave's place in Marseilles.

Everything seemed to be going smoothly even as we got to Wrigley. We were pushing it to make it in time for the first pitch, but we were definitely going to make it before the end of the first inning. Dave waited in line at the will-call while we stood off to the side. He finally came back with an envelope of tickets, and we started to head inside. Before we could get to the gate, Dave noticed the tickets were for a game in late August, but it was early May. So back to the will-call he went. Less than five minutes later, he walked back toward us with another set of tickets. Somehow there had been a mix-up in the ticket office.

Equally iconic although somewhat less famous, this recognizable marquee hangs over the bleacher entrance. This marquee is the backside of Wrigley's famous scoreboard. Standings, represented by team flags, for the National League's three divisions sit atop the scoreboard. The flags are also something every pitcher checks when they arrive on game day to see which way the wind is blowing. *Jenkins Imaging.*

"I have no idea where these seats are at," Dave said shaking his head.

We headed inside and kept walking as we tried to find our section. At no time did any of the three of us pay attention to what row we were in. We found the section and then our seats, which were in the front row behind the Astros bullpen! Needless to say, the Cubs more than made up for the mistake by giving us way better seats than what we were expecting by seating us in the front row. That night I saw Kerry Wood return from the disabled list, have a nice outing against Houston and even hit a home run in his first at-bat back from being on the shelf.

Oh, and I passed my final exam and graduated later that month.

6

BOYHOOD DREAMS FULFILLED AT WRIGLEY

JOE GIRARDI, NEW YORK YANKEES MANAGER/CUBS CATCHER, 1989–92, 2000–02

My first memories are as a little boy cheering for the Cubs and going to the ballpark with my father to see my favorite players—Ron Santo and Jose Cardenal—and getting the Ron Santo pizza at the park. He was a neighbor of mine when we lived in Chicago, so that bond was always special. I remember riding in the car and listening to games on the radio during the summer with my father, who was a salesman. He would take me with him, and we'd listen to the games. He was emotional about his Cubbies, and I still have that passion for the Cubs that I always had. I always cheer for 'em—except when they play us. Then being able to reach that dream, being able to play for the team you dreamed about as a little kid—that doesn't happen very often. I know there are a lot of kids who dream about playing in the big leagues, but the chance of playing for the team that you loved and adored is probably not great.

I often think about my first day. What a thrill it was for me when Don Zimmer told me a week before that I had made the team but that I couldn't tell anyone quite yet, which was very difficult. I remember being extremely nervous that first Opening Day at Wrigley in 1989 with Sut telling me, "Don't worry, kid. I got ya. I know these Phillies." He told me Bobby Dernier never swung at the first pitch, and after one pitch, he was on first base. Mitch Williams comes in with a 5–4 lead in the ninth inning with the bases loaded and nobody out, and he ends up getting out of it. The topper for me is that I got engaged that night after the game. My wife and I have been married almost twenty-four years. She grew up a Cubs fan, and I grew up a Cubs

fan, and it's worked very well. For me, to start on the Opening Day roster and then come back and be part of the playoffs, it was a dream come true. I really couldn't write it any better; the only way you could probably write it better is if we won the World Series.

The history at Wrigley stands out, as does being able to go to the ballpark you went to as a little boy—the place where you dreamed about being on the same field as your heroes. I still remember seeing Ron Santo and Jose Cardenal coming over to the brick wall to sign autographs and yelling at them all the time to come sign.

Coming in as a player, I was interested in the clubhouse, but the clubhouse was different when I was a little boy because it was down the left-field line in those days. The cage under the right-field bleachers was always something. I was like, "Look at the cage underneath. Is it heated? Are they freezing in there?" And the grass. I wanted to see the grass because there's something about Midwest grass that's very thick. The Cubs infield was always high, which made it just a little bit slower.

From the visiting side, the tunnel you take from the clubhouse to the ballpark is interesting; you're not used to going down and up. Walking on the field and seeing the people in the bleachers and how much fun they have out there is something you have to experience. When I was a player, it was fun to see Roger McDowell come in and spray the people.

The thing I'll remember the most was being at the brick wall yelling for autographs. Then to be on the other side was pretty neat. I always love coming back. We still have family here. The fans have treated me very well; they've been very gracious and very good to my family. Whenever I go back, it's that warm and fuzzy feeling you get because of the way people are.

My thought about renovating Wrigley is that they're only trying to make the experience better for both the players and fans. I don't think you're going to see the guts of the ballpark changed. They're still going to have the brick wall and the ivy and the same dimensions. I think the experience will be better. Some people are traditionalists, and I understand that, but for the most part, people are going to like it.

A FIRST DANCE AT WRIGLEY

CINDY MORRIS, SAN DIEGO, CALIFORNIA

My first trip to Wrigley was in 2013 for a Cubs-Cardinals game. It was amazing to see the park, and I love how it's in the neighborhood. I'm a Padres fan. Wrigley is very different from Petco Park, which is

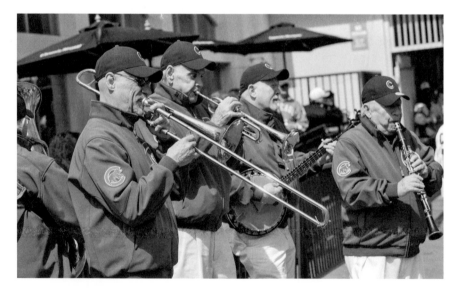

A four-piece band plays for fans entering Wrigley. For years, the band played inside the park in different sections between innings. *Jenkins Imaging*.

down in the city. This park obviously has lots of history. It's interesting to see the difference in the field, the stands and the concessions. Before the game, I stopped to listen to the little band outside the park, and before I knew it, I was dancing with Ronnie "Woo Woo." I just got swept off my feet.

8

WRIGLEY, THE KIDS' PLAYGROUND

JEFF SANTO, SON OF CUBS LEGEND AND HALL OF FAMER RON SANTO

Wrigley was a playground to me and my brother Ronnie. It was summertime and our childhood. We would go to as many games as we could in the summertime; we were a fixture at Wrigley Field. And there weren't many kids who went down there. We never watched the games. The minute we got there, it was grab some gloves and a ball and go out to the backstop to play this game where we'd throw the ball up on the net that went to the broadcast booth to see if we could catch it.

I just remember Wrigley as such a beautiful place in the summertime. It was basically our whole childhood. We'd bring friends, and it would be an experience of a lifetime for them—meeting the players, hanging out in the locker room. We got to know so many people. My brother and I were regulars at the firehouse across the street, hanging out and going down the fire pole. Back then, the clubhouse was down the left-field line. My brother and I would watch the games out of that corner door.

When my dad passed away, we were in Chicago for his funeral and I remember watching WGN when they showed my dad clicking his heels and disappearing into that locker room door in the left-field corner—and there was my brother and me with our heads sticking out of the door waiting for him to come in. It was quite a moment. I saw that for the first time after he died. We went to Wrigley after my dad passed away. I just went to the ballpark and went inside that old locker room. I can't believe they fit a whole team in there. It's not used by the team anymore, but it was my dad's locker.

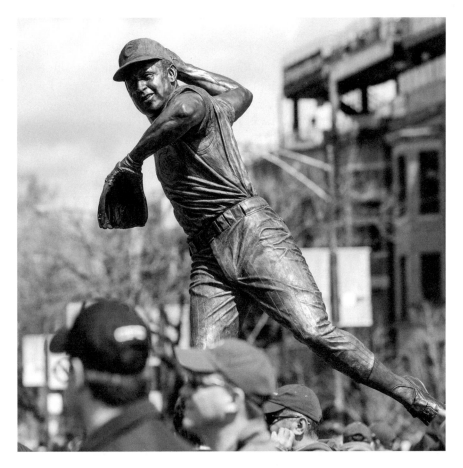

Ron Santo became a fan favorite as a player but grew to iconic status as the color commentator on WGN Cubs radio broadcasts. The Cubs retired his number in 2003, and Santo was finally inducted into the Baseball Hall of Fame in 2012. *Jenkins Imaging*.

The park was magnificent—an awesome place. I can still remember walking out there when no one was on the field except for my brother and myself, the smell of the grass, all the time alone on the field even before the Cubs came out for batting practice. Every morning when the sun was rising, we'd walk out that left-field locker room door, and it was like, "Wow, look at this playground. What do you want to do now?" And we'd just take off. My dad just let us be. In the dugout, if you take a left, there was the umpires' locker room. Now it's the regular locker room. There was this very low corridor—a kid could walk through it. They had all this junk back there—old equipment, grounds crew equipment—and we'd take this

31

tunnel all the way to the visitors' dugout. We were exploring the depths of Wrigley Field like the Goonies. The first time we found it, all of a sudden we're seeing these big Pittsburgh Pirates players smoking and talking with their bats and gloves. I don't think many kids ever found that place. For us, it was like, "Hey, let's go through this little tunnel to the visiting dugout and hide behind these pillars and watch Johnny Bench and Tony Perez walk by." When the Giants came to town, it was Willie Mays and McCovey. It was our little place to see the visiting team up close and personal.

As an adult, the park hasn't changed much. To me, it's still the same. To me, it's home. I don't have a home in Chicago anymore, so I go to Wrigley and get emotional now that my dad is gone. And now that my dad's statue is out there, it's always special to walk over there and look at it. All the memories just flash back because they are so vivid to me still. I look back at it as an adult and say, "Wow, what a childhood I had." It was what I grew up with. We were fortunate to be able to wander around Wrigley Field wherever we wanted to. I remember one time an Andy Frain usher said, "Son, you can't go down there," and I said, "Really, watch me jump over the wall on to the field and try to catch me." It was one big family, so I have a lot of great memories of all the guys—Ernie, Glenn, Billy, Fergie and Kess.

I think of Wrigley as this daytime and sunshine. For my brother and I, it's a different feeling. We were on that field as kids; we had so much fun. People wouldn't understand how big that is. Looking back at it as an adult, I go, "Wow, we had something very special." And that was Wrigley Field.

THE SANDBERG GAME

BOB COSTAS, LEGENDARY NBC SPORTS BROADCASTER

Late in June 1984, the Cards and Cubs were playing on the NBC "Saturday Game of the Week"—back when the game of the week drew large audiences and truly was appointment viewing for baseball fans. A beautiful Saturday afternoon at Wrigley with the two friendly longtime rivals—not an often-bitter rivalry like Yanks/Red Sox—would be appealing enough. It was a sun-drenched afternoon with splashes of Cardinal red mixed in among all the Cub fans. But what unfolded made it unforgettable.

At one point, the Cardinals led 9–3. Ozzie Smith had turned in two spectacular fielding plays, and Willie McGee would eventually hit for the cycle. But the Cubs fought back and were trailing 9–8 as they came up in the ninth. The problem was they faced the National League's premier closer, the Cardinals split-finger specialist and eventual Hall of Famer, Bruce Sutter. But Ryne Sandberg homered into the bleachers in left center to tie it. Then, after the Cardinals got two in the top of the tenth, Sandberg came up again with two out and a man on in the bottom half. With Sutter still pitching, Sandberg homered yet again, so close to the same spot that the same fan could have caught both home run balls. I can still see an angry Sutter snatching the new ball thrown to him by the plate umpire as Sandberg rounded the bases with Wrigley in a state of delirium. It was part of a five-hit day for Sandberg, which established him on the national stage and launched him toward the MVP award.

The movie *The Natural* had only recently come out, and I recall saying to Tony Kubek, "Maybe this kid is the true Roy Hobbs." In any case, the

Prior to bleacher renovations in the mid-2000s, the bleachers stretched only to the existing brick-wall perimeter, allowing for many home run balls to literally leave the park and end up on the street. Chain-link fences extended up several feet above the wall, providing the only barrier to keep well-hit balls from exiting Wrigley. *National Baseball Hall of Fame Library, Cooperstown, NY.*

Wrigley's upper deck offers a wide variety of vantage points of the field, the neighborhood and beyond. Looking east, Lake Michigan is visible from several spots in the upper deck. *Dan Campana photo.*

Cubs finally won it 12–11 in the eleventh on a single by Dave Owen. That last part is largely forgotten, but the game itself has ever since been known as "The Sandberg Game." To this day, especially in Chicago, I still hear about it. Someone will start a conversation with, "Hey Bob, remember the Sandberg game?" Well as you can see, yes I do. It was one of the most enjoyable and remarkable regular-season baseball games I've ever witnessed, made all the more perfect by the two teams involved and the perfect setting: Wrigley Field.

10

THE "JERK" WITH THE CELLPHONE

GLENN SCHORSCH, CUBS FAN SINCE BIRTH (1959)

My first recollections of Wrigley involve my four elder brothers, an elder sister and a younger sister. We grew up near Addison and Oak Park Avenue on the Northwest Side of Chicago. We'd take the Addison bus to Wrigley. It was a straight shot to Wrigley on that Addison bus. It was extremely inexpensive, as was getting into the ballpark. Ticket prices were such that we usually sat in the grandstands or bleachers. Grandstand seats were probably a buck and a quarter.

I grew up with players like Ernie Banks, Ron Santo, Billy Williams, Don Kessinger and all those guys, so there was always a lot of promise every summer that those teams would be getting to the World Series. Of course, we know what happened. I remember the Fergie Jenkins–Bob Gibson matchups—those were always exciting. And we always made it a point to go to games when the Giants came to town, with Willie Mays and Willie McCovey, or the Braves with Hank Aaron. As a young child, there was always the thrill of just getting to the ballpark. We never had an issue getting tickets in those days. We could always walk right up to the window and buy our tickets. Although they were crowded, the games were never sold out.

After one of the games when I was a young boy, I saved all the beer cups I could and took them home, two stacks eight feet high. I used those paper cups on my fence in the backyard to write "Go Cubs." I remember getting strange looks on the Addison bus, people watching this little kid carrying all these beer cups. My intent was to duplicate the left-field bleacher fence in my backyard. Those were looks I'll never forget.

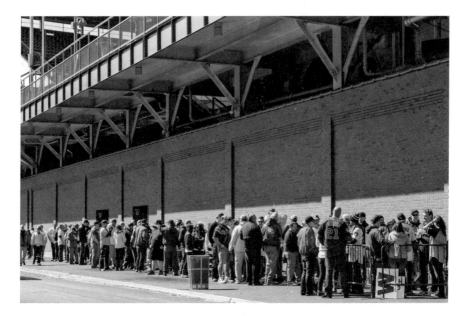

Bleacher lines extend down both Waveland and Sheffield before the gates open on game days. *Jenkins Imaging*.

With the teams of the mid- to late '70s, the stands were much less crowded. You could buy a ticket and walk right down to the front, and the Andy Frain ushers allowed you to do that. My first foray into the box seats was because the park was so empty. Then, of course, it all changed with Dallas Green coming in, Harry Caray joining the team and the Sandberg years. I had a few opportunities to go out to the center-field bleachers when I knew Harry was going to be out there. I was amazed to see that Harry brought his own cooler with him with cans of beer in it.

I was at the Andre Dawson game when he got beaned in 1988—the game when the mailman got the home run ball. Before things got crazy around Wrigley, I used to be able to park on Waveland Avenue. One time, I think it was a Ryne Sandberg home run that bounced across the street and hit my white Suburban. It was a highlight on the local news, so when I was asked later in the day—because I was "working"—what I did that afternoon, there was video evidence of me playing hooky.

In the 1980s, I finally got to the front row, and I spent half of the home season there. Probably in 1985, I went to the ballpark with one of the early cellphones—one of those brick phones. It was a novelty. I had it with me while sitting in the first row by the visiting dugout, right next to the on-deck

circle. During one game, a player asked what it was that I had. I told him it was a phone. The player had never seen one. He asked to look at it and then took it in the dugout. He came back and goes, "You can call anywhere?" I told him yes and that anyone could call you on it. Arguably, I was the jerk who brought one of the first cellphones into Wrigley Field. Now everyone is on his or her cellphone all the time.

Only recently did I get to step onto the field and cross that off my bucket list. Crossing that barrier and stepping onto the actual grass is a feeling you can't explain. You're on Wrigley Field on game day. It's something every true fan should get to experience in his or her life. It's like you're on a special carpet. Each of us still has the child inside, and when you're at Wrigley Field, that child comes to the forefront. It always brings you back to your first visit to Wrigley. That repressed child cannot hide in the Friendly Confines.

THE WRIGLEYVILLE FIREHOUSE

LIEUTENANT JOHN SAMPSON

I've been here at Engine 78, the firehouse across from Wrigley, for thirty-three years. We're busy, so it's a good place to learn how to be a fireman. With the ballpark right there, it's an interesting place in the summer. We got pelted by balls hitting the rig at Kenmore and Waveland on a run when McGwire and Sosa were hitting balls during batting practice in 1998. In the winter, you live in a garage. It's tough.

You couldn't walk the neighborhood back when I started; you were gonna get shot, stabbed or robbed. And we had a lot of fires. Back then, in the '80s, we had arson for profit. We were fighting fires left and right. Now it's totally changed; it's family oriented, it's a destination. From the middle of June, that's when the people from around the world come here, and it ends about the middle of August, when they all go back to school. That's when the regular Cubs fans come back.

When it comes to stories, we've got to start with Ernie Banks. Thirty-three years ago, he came up to the firehouse before an old-timers game. He came up to my lieutenant at the time and wanted to know if he could borrow a black belt for his uniform. Because I was the rookie, the lieutenant goes, "Hey Sampson, let 'em borrow your belt." And I go, "No." He says, "That's Ernie Banks." I said, "I don't care. I'm not gonna see it again." Eventually I gave him my belt, and that's the last I saw of it. The belt I'm wearing now has thirty-two years on it. Every time I see Ernie when he brings in his grandkids, I say, "Ernie, how about that belt?"

Each shift will work about twenty games per year. One day, Ron Cey hit a foul ball that rolled into the kitchen of the firehouse. I'm sitting there in a recliner and I just leaned over, grabbed it and put it up in the locker. About fifteen years later, that ball is still sitting up there, and this fireman comes in with his ten-year-old son. They had gone to the game, but afterward the kid had his head down, looking kind of depressed. I asked him what was wrong, and his dad goes, "He came that close to getting a foul ball." So I went back to my locker and grabbed this cruddy old ball. I told him, "Back in the '80s, long before you were born, this was hit into the firehouse by Ron Cey. This is yours." The kid just lit up, and that's what you want.

SPIDERS, A SUMMONS AND A SQUIRREL IN THE BOOTH?

STEVE STONE, CUBS PITCHER (1974–76) AND CUBS TV ANNOUNCER (1983–2004)

I played at Wrigley for three years and worked there for twenty-one. I was one of the guys in the trade for Ron Santo with the Sox. I've always described it as a trade that hurt both teams. Ron played only one year with the Sox before he retired, and I was a twenty-game winner for the Cubs—but it took me three years to win twenty-three games. Unlike most fields, because of the low bleachers, the wind really affected the ball at Wrigley. If it was blowing in, it was hard to hit the ball out. But when it got warm and the wind was blowing out, as soon as it got above the stands, the ball just rocketed out. Whether it was the 368 in the power alleys or down the line, it really didn't matter much.

In July 1974, with the wind blowing out, I gave up five home runs—five solo home runs—to the Big Red Machine in two and a third innings. The record at the time for homers given up by a single pitcher in a single game was six. I knew this because when you pitch at Wrigley Field you realize you are going to give up some home runs if you don't throw sinkers—and I didn't. Jim Marshall, the manager, came out and said, "I think that's enough." I said, "The record's six and I'm only in the third inning." And he says, "No, I think that's enough." He took me out of the game, and I couldn't break the record. I was most disappointed.

This was a rare occurrence. Before they put in the new clubhouse, they had the old clubhouse down the left-field line. I remember walking in after a game and a guy who I didn't recognize walking up to me. He asked, "You're Steve Stone?" I said yes, and he served me with a summons. How he got in

there I have no idea, but he did. I was maybe one of the few guys served a summons in the confines of the locker room in a ballpark that ostensibly had some security. That was certainly one of the highlights of my career there.

Even though I was a player there from '74 to '76, I didn't appreciate Wrigley Field as much for the aesthetics and everything that goes with it as I did later when I became a broadcaster. I got back to Wrigley Field in 1983. Harry had gotten there in 1982. I was one of the names Harry gave to Jim Dowdle, and I wound up being his partner—his last partner. We were together for fifteen years. He taught me how to do local baseball and a whole lot of things about the business. I think it was his ability to sell—and he was the best at it—Chicago, Wrigley Field, the Cubs and the whole experience. And he sold Harry Caray in the process. It was that perfect storm that came together in 1984. Harry always talked about planning your summer vacation around coming to Chicago, this wonderful city with so much to offer. He said while you're here, you have to stop in to Wrigley Field. He'd say this is what baseball is all about, baseball like it used to be. With Harry, his palette was Wrigley Field. That was his last stop. He came to Wrigley Field, and that's when he went from that lovable local broadcaster to a national cult hero. He always told me that when they're bad on the field, we have to be much better in the booth.

Oh yes, the booth. There were continuous wasp infiltrations in the booth. After Harry had his stroke in '87, I began doing the postgame interviews. One game, I was trying to do the postgame, and these wasps were flying everywhere. I remember bringing wasp spray in and having Sharon Pannozzo, the media relations director, come up yelling at me because the spray was going in the upper deck into everyone's beer and drinks and hot dogs. Then one night we had the ceremonial hatching of at least one thousand spiders. They were all over the booth—everywhere. It was everything you could think of that went on there.

One of the greatest recollections comes from something I didn't originally know about: Ronald Reagan coming to the ballpark. They told Harry, because he was wearing a jacket and a tie to a day game, which was really unusual. The only time he wore a jacket or tie was in New York and Los Angeles when he'd go out after night games. So, Arne Harris tells me to keep on talking because it's now 1:20 p.m. and the game is supposed to start. We were in the old booth, which was down the third-base line hanging underneath. So I'm looking at the camera and talking with Harry, but Arne wouldn't tell us that the president is coming. Then, all of a sudden, there's a tail in my lap, and I literally thought a squirrel had dropped down from the

rafters. And I was talking and talking and thinking that if I reached down and it is a squirrel and he bites me, then I gotta catch the squirrel because I might get rabies shots. In the meantime, I'm trying to talk intelligently into that camera. I figured I had to find out what it was, so I reach down and I've got a nose and a muzzle in my hand—it was an explosive-sniffing dog. The Secret Service was bringing the dogs through before the president.

During that game, I had to make a big piece of paper with a "B" on it and another with an "S" on it, and I had to point to one or the other so that the president could call the pitches. He said he couldn't see because of the glass, and I said, "Mr. President, there is no glass." He said, "Well there was some here the last time I was here with Pat Pieper." Pat Pieper was the guy with the megaphone who would walk around in front of the seats yelling the lineups, and that was in like the 1930s.

Then there was the time Hillary Clinton came to the booth. When she was introduced to me, I shook her hand. When she was introduced to Harry, he planted one right on her lips. The look in her eyes when Harry gave her that big kiss right...well, I'm not sure how often that happened to her, but I know it was a tremendous surprise.

13

COMING FULL CIRCLE IN WRIGLEYVILLE

BILLY DEC, OWNER OF ROCKIT BURGER BAR

First of all, not many people were actually born and raised walking distance from Wrigley. I grew up at Orchard and Deming, south of the park, but we actually used to walk there for games as kids. That's kind of a cool experience because as a kid, you're usually confined to just a couple blocks. I was an altar boy at St. Clement, and the church used to take some of us to the games. We'd walk to the games with the priest and the people who worked at the church. That's my first amazing memory of Wrigley: being with those types of people, walking up to historic Wrigley Field and sitting right there along the first-base line. I don't know why we had such great seats. Well, I didn't know if they were really great or not, but that's how you absorb it—the best seat in the world.

I used to love Bill Buckner; he was my guy. At first, it was because my name is Billy and his name is Bill. But eventually I started loving him because he was awesome and turned out to be a pretty good player. When I played Pop Warner football, I'd stand out there to sell candy bars to make money, which was great because the drunk yuppies would throw the money. To throw two bucks at me back then was the biggest deal in the world.

Another thing I remember was the sun just beating down on us during the game and getting to eat all that awesome ballpark food. Anytime you heard organ music, it felt like it was from another time. It was pretty fantastic.

When I came back from college in the mid-1990s, it was like a totally different place. To me, everything had changed. Coming back as an adult, we started going to the park to drink in the bleachers and to bring dates

there. It was a very adult place but also sort of a crossover place—you were still a kid, but you were having fun on a date or with your buddies drinking beer in the bleachers because that's all we could afford at the time.

It wasn't until I really started traveling the country and all over the world that I realized how unique not only the stadium, the team and the fans were but also the unique mix of all the things involved—the residential, the commercial and the traffic flows. Everything is so unique. As I grew up, I began to respect it more and more in different ways to the point where as I did TV and other philanthropic events, I started getting invited to do things like throw out the first pitch. The first time, I almost had a panic attack. Just walking out there…I turned into a little kid again. I just melted and lost it. I'll never forget it; I pitched to Derrek Lee!

From a business standpoint, I always felt there was a huge light that shined on those corners. It was like a curtain opened, and to me, the whole world was there making memories. For selfish reasons, I thought it would be really cool to have a place there just so I could be immersed in that culture. I feel like Chicagoans want the best of the best but that they want it in the most comfortable ways. I wouldn't put a fancy restaurant there, and I wouldn't necessarily put a dive there. Rockit is an all-American brand with ease and comfort in mind, which I thought was kind of what Chicago and the Cubs were all about. I wanted really great food and to make people feel super comfortable. You can literally just sit there and watch the scoreboard from the tables outside. It was kind of a no-brainer.

We started with a full menu, but it felt like the Cubs fans were very particular about the experience they wanted. They didn't want to use steak knives or eat salmon and gigantic salads. After two years, we found that 90 percent of everything ordered was a sandwich or something you held in your hand—80 percent was a burger. So we came up with sixteen high-end, gourmet burgers, and it took off to the point where in a 120-seat space, we were doing six hundred burgers before and after the game.

It's a whirlwind every game, and you're just part of it. There's always an immense physical rush of people through the doors, and it's the emotion and vibe they're all giving off. It's unlike any other bar/restaurant experience. During a Cubs game, the vibes and emotions people give off are those of excitement—jolly, silly, peaceful excitement. It's really interesting when you're immersed in it.

We've had a ton of celebrity guests at all our restaurants. Many of them like to go to Cubs games, so it's been an awesome place to entertain. We'll have everyone from hardcore Chicagoans come in, like Jeff Garlin or David

Diners at Rockit Burger Bar can keep an eye on the Wrigley scoreboard from the restaurant's upper level or sidewalk tables. *Jenkins Imaging.*

Schwimmer, to Billie Joe Armstrong from Green Day and different bands playing at Metro or bands that are singing the seventh-inning stretch. For them, it's become their home after the game. For Cubs players, we've done everything from hosting philanthropic events to running food to the players. I would keep the kitchen open late if the players were texting me saying they wanted to pull up and grab something on the way home. If I felt it might be too crowded, I'd just send one of my guys to run a bag over to the gate where they pull out. Derrek Lee would actually pull up and go in the kitchen. Cubs fans would have freaked out if they knew he was on the other side of the wall putting together his burgers for his ride home.

There were times where, as a family, we did fine and had money, but there were also times when we didn't. With that in mind, I've bought hundreds of tickets at a time to give away to those people who didn't have money to have those experiences. I'd literally take groups of hundreds of people to eat at Rockit, and then I'd take them to the bleachers and just try to share the experience with people who haven't been able to do that before. Also, I would pick certain people who do really great things to join me on the field when I would throw out the first pitch, because you get a couple guests. I know that's an amazing experience for anybody. I'd bring them on the field, and they would freak out.

14

BRINGING WRIGLEY HOME

JACK ROSENBERG, WGN SPORTS EDITOR, 1954–99

Philip K. Wrigley was certainly a prophet. He had people tell him that if he put the Cubs on TV, it would affect gate attendance at Wrigley Field. But Wrigley knew television was the future. He knew how to promote baseball, and he knew baseball would go hand in hand with television. He was right, and television has been a phenomenal part of the game ever since.

My first memory of going to Wrigley was to go to work. Jack Brickhouse, who at that time I knew only casually from a couple dinners, called me and said, "Hey, kid. I know you want to work for the Tribune Company. We got an opening in television and radio—you would fit perfectly. You'd be right alongside all of us up there in sports." I said, "Mr. Brickhouse, I'm a newspaper man. I've never been around television or radio." The next day we talked at his house in Wilmette for three or four hours and connected immediately. Three weeks later, I'm working in Chicago in television and radio for eighty-five dollars a week. Ernie Banks's first season was in 1954. That was my first season, so we were together all that time.

In 1962, we did the first transatlantic telecast to Europe. It was a game against Philadelphia at Wrigley. I can still hear Jack's voice saying, "Ladies and gentlemen, we are about to televise the first baseball game to Europe—the Cubs and the Phillies." The crowd wasn't big, but they really sat up and took notice. We carried just a few minutes of that game. This is all a part of Wrigley's history.

One of the great moments for me was when Ernie Banks hit his 500th home run. We knew for days it was coming; I kept stockpiling the home runs leading up to it for shows. I remember how busy I was the day he hit it. The no-hitters stand out, especially Holtzman's in August 1969. When that game

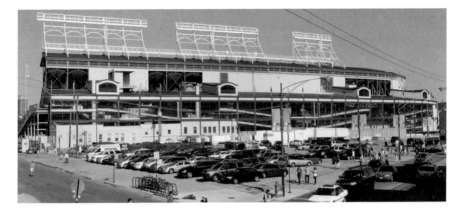

For many years, Wrigley's so-called Triangle property was home to a car wash and a restaurant. The Cubs operate an ice-skating rink there in the winter and use it for parking during the season. The players' parking lot sits in a fenced-off area just off Waveland. Television production trucks also are positioned there. *Jenkins Imaging.*

was over, we knew the Cubs were in. Santo hit a three-run homer in the first inning, and it held up.

In my opinion, the '69 Cubs will have a special place in Wrigley's history no matter how many centuries have passed. They had a certain something with the personalities of those ballplayers that was unbelievable. I still have a mental picture of them standing there signing autographs or standing in the parking lot after the game signing. It was a very unique time because everyone was positive that the Cubs were going to win. We were part of it, and it was difficult that this could happen because you were talking about a tremendous team.

Wrigley Field and everything in there is just a place of great comfort and fun. In my early days, you could get all the tickets you wanted. We used to run everybody in there—all our friends—and ask them where they wanted to sit. That's how loose they were with tickets. There was always a staggering aura at Wrigley Field, and once you went there, there was a good chance you were going to be hooked on it for years to come.

I wanted to be there. There was always a tinge of excitement even when the Cubs were losing, which they often did. To go out there and be around your friends every day…to be around Jack, Vince Lloyd, Lou Boudreau and Lloyd Pettit, you could hardly wait to get there. To see the kids, young and old, come out with their fathers and grandfathers—we would watch that. I don't think the excitement ever wore off.

I would say if you look for a place that is unlike any other place in the world, you will find yourself on the doorstep of Wrigley.

UNEXPECTED BEGINNING, HISTORIC FINISH

MIKE CONSIDINE, CUBS FAN FROM MICHIGAN

In 1969, there was a lot of buzz about the Cubs. That might be the explanation for a phenomenon I can't otherwise explain. Whatever the reason, my father approached me on August 19, 1969, and asked if I wanted to go to the Cubs game that day. We'd lived in the Chicago area for about two years, having moved from rural Michigan, and I don't remember him ever mentioning the Cubs or Wrigley Field before that moment. For that matter, I'm not sure he'd even verbally acknowledged the existence of the National League. My dad was a very introverted man who never said much. He certainly had never suggested that he would be amenable to seeing the other Major League team in town.

See, we're Detroit Tigers fans. My father, Louis Considine, was a lifetime Tigers fan. He died two years ago.

At any rate, we'd gone to a handful of White Sox games, some involving the Tigers, in those two years. I didn't really understand it then, but he was only taking me to baseball games because he knew I loved the sport so much and it seemed the right thing to do. My dad loved it, too. He played in high school and even played in old-timers games in the Lansing, Michigan area up until the late 1960s. Before that, he volunteered for the U.S. Army Air Corps as soon as he could after high school. He became a tail gunner, flying bombing raids over Europe in World War II. When he came back home after the war, he played semi-pro baseball. Dad never said as much, but I always accepted the fact that he believed he would have played pro baseball if not for the war. It was a big dream for a five-foot-three guy, but I'm convinced he clung to it all his life.

My story was much different. Like any other Chicago-area elementary school kid, I would rush home from school during baseball season in hopes of seeing the last few innings of the Cubs game on WGN. I did my best to learn everything I could about the team—from appreciating the seemingly flawless defense of Don Kessinger and Glenn Beckert to the flair Fergie Jenkins demonstrated on the mound to the remarkable consistency of Billy Williams and the joy Ernie Banks brought to the ballpark each day. I can't say I was in the process of becoming a Cubs fan, but they had quickly become one of the teams I cared about.

That said, I couldn't possibly have responded affirmatively any faster when my dad broached the subject in August 1969. Heck yes I wanted to go to my first Cubs game, and as it turned out, it would be the last we'd attend together. It was perhaps the last Cubs game he ever went to—I can't really say for sure.

I'm sure I knew Holtzman was scheduled to pitch that day against Hank Aaron and the Atlanta Braves, but I definitely didn't entertain the idea that he might pitch his first no-hitter. I had no idea that he'd flirted with one in 1966 while we were still in Michigan.

As we parked the car on a not-too-distant side street and dad paid some neighborhood teenager a few bucks to watch the car during the game, I could barely contain my excitement. I wanted to see the ivy in person. I wanted to admire the sculpted greensward and see if the park was really that much smaller than old Comiskey (yup, it sure was). And I wanted to sit among the Bleacher Bums.

By the time we got to the box office, and this was possibly the only time we went to a game without tickets, it was a sellout. We found our best option to be part of the standing-room-only crowd around the Braves dugout. It turned out to be a fairly good location. I certainly didn't mind standing. Dad probably did, but he never complained. In life, he assessed the situation he found himself in and silently coped as best he could.

I wish I could remember the game details vividly. The truth is that all these years later, I don't remember much about how the game unfolded. I don't recall how the Cubs scored. How could I forget that a three-run home run by Ron Santo accounted for all the scoring that day? I also don't know when I started sensing a no-hitter. But I vividly recall Aaron—back when he was still an underappreciated perennial All-Star and not the steroid-free all-time home run champ—coming to bat with two outs in the ninth. I remember him fouling off a few pitches, including a foul ball that went over our heads and landed about fifteen rows behind us on the left. The rest of the crowd was on its feet for that at-bat, all of us sensing that Aaron was more than

capable of spoiling Holtzman's achievement before it could enter the record books. The nervous tension in the crowd was palpable.

In his previous at bat, Aaron had hit a drive that probably should have left the park, but the wind held it up just long enough for Williams to haul it in with his back to the vines.

So, Hammerin' Hank was due, and I was convinced nothing historic would happen in my first game at Wrigley.

Somehow, though, the twenty-three-year-old lefty found a way to induce Aaron to ground out, preserving the no-hitter.

I still can't believe we happened to go on that particular day, if at all. By the time my own playing days had ended, that is to say by the time I was fifteen, I couldn't talk my dad into going to any baseball game—not even a Tigers game. That makes it all the more amazing to me that on August 19, 1969, he stood by my side while we saw Holtzman pitch probably the greatest game of his life. Yes, there was a second no-hitter in his future, but the first one has always seemed more special to me. The first one is arguably the high point of a season most Cubs fans expected would end with a drought-ending 1969 World Series championship.

16

MEMORABLE MOMENTS ON THE MOUND

RICK SUTCLIFFE, CUBS PITCHER (1984–91)
AND ESPN ANALYST

I'm into old. I'm into the history of the game. With Wrigley, there's the charm of what happens to that place when you fill it with people. You go there in the winter, and it's cold and windy. If that were the only view you had at Wrigley, you would wonder what people see in this place. But if you go there on a Saturday afternoon to watch a Cubs-Cardinals game when they're both in contention, I don't know that baseball gets any better than that.

It's funny thinking about the clubhouse and the walkway. I'm six-foot-seven, and as I would walk from the clubhouse down that runway, you could tell that people back when they built it were a lot shorter. Guys like Lee Smith and myself were constantly banging our heads throughout the clubhouse.

Before Game 1 of the 1984 playoffs against San Diego, everybody in the world was trying to get tickets. I'm a big country music fan, and the group Alabama were real good friends of mine. At the last minute, they freed up their schedule so they could make it to the game. I needed to get eight tickets for them, but of course the front office said they didn't have anymore. I had my agent call Dallas Green and say, "If you don't get these tickets for Rick, you got no chance of resigning him." I believe their tickets were better than my wife's.

Pitching well in Game 1 was one thing, but when I hit the home run, it was kind of like, "What in the world was going on here?" I'd been in the American League and hadn't swung a bat in a long time. I remember the next morning going to get a newspaper and seeing a picture of my wife and

mother-in-law with both of their mouths as wide open as they could be. If I shocked my wife like that, I'm sure there were forty thousand other people who were even more shocked. We had a strategy for Eric Show that day to make him get the ball up with the wind blowing out and to get the barrel of the bat on the ball. Fortunately, a lot of us did that day.

I actually knew that I would be starting the first night game at Wrigley on August 8 around the All-Star break in July. Right after the break, I was told about that game. I think people started figuring it out a couple weeks before. The next thing you know, everybody in the world was calling for tickets. A great friend, Mark Harmon, was able to come in for it. There was also Bill Murray and a lot of former Bears and Blackhawks—I was scuffling to get tickets for all those guys.

Then, all of a sudden, the PR department comes up to me—and everyone knows no one talks to me the day I pitch. They had a representative from the Hall of Fame with them, so I say, "Well, whaddya want?" They said they wanted the first ball to go to the Hall of Fame, and I said, "What does that mean?" They didn't want it fouled off or put in play, they said. I was getting kind of pissed off and said, "Just speak English to me." They explained how they had talked to the home plate umpire, Eric Gregg. I said, "You're telling me that if I throw the pitch six inches outside and it's not high or low, he's going to call it a strike?" They said yes. If you go back and watch the first pitch, I nailed the glove. It was the first time I ever saw everybody in the ballpark take a picture at once—especially of me. I didn't know what happened; I thought it was my nerves. I had pitched ten Opening Days, pitched in the playoffs and All-Star games—why would I get nervous? Harry Caray thought there was an explosion or something. Right along with that was the fact Eric Gregg called the fucking pitch a ball. I did exactly what I was told. Years later, Gregg told me that as I was winding up, he knew the whole world would be watching. He saw all the extra cameras that were there and thought, "I can't miss this first pitch—I'll look like an idiot." So instead of him looking like an idiot, for a moment, I did.

Of course, on the mound after it happened, I'm still confused and pissed off at Gregg—and then I give up the home run to Phil Bradley. I told myself I needed to get my act together because this was not a game I wanted to screw up. I had pitched the top of the fourth, so I needed to go back out there for three more outs to qualify for the win since we were up 3–1 when the rain started. I think it was a two-hour rain delay, and I continued to stay warm and throw baseballs in the little tunnel for the entire two hours. I thought I was going to have to go to the emergency room because I was so

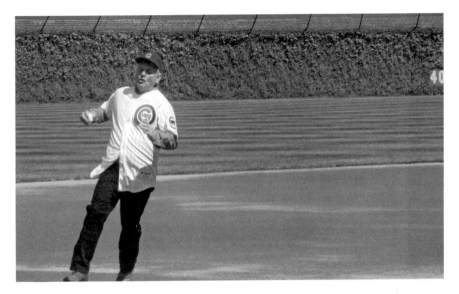

In one of the most unconventional Opening Day first-pitch ceremonies, actor Bill Murray ran the bases and slid into home plate to get the crowd going in 2012. *Paul Johnson photo.*

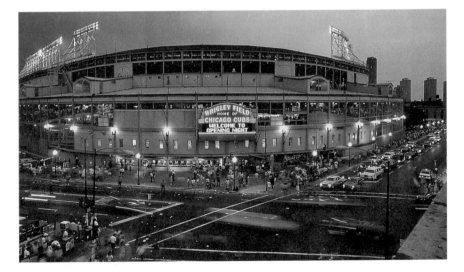

Wrigley Field and Wrigleyville buzzed with anticipation of the first night game on August 8, 1988. A thunderstorm caused the contest against Philadelphia to be rained out after only three and a half innings. The Cubs defeated the Mets the next night in Wrigley's first official night game. *Bob Horsch photo (www.horschgallery.com).*

drained. I kind of dehydrated myself trying to stay warm. I was going back out there no matter what.

There are a few monuments at Wrigley Field. Somewhere down the line, someone's going to remember that Dallas Green was really the man who put it all together there. He's the guy I feel is more responsible than anybody—he just had such a passion for winning. He did everything he could to turn that organization around. I honestly don't think I played in front of an empty seat. I've got to be honest, I just don't think Dallas Green has ever come close to getting the credit that he deserves for the way things turned around. I can remember coming to Wrigley as a visiting player in 1981 and there weren't a whole lot of fans there. In '82 and '83, I was in the other league, so I don't know what went on. But I know that in '83, the Cubs did not play well, and I imagine they did not draw well either. Dallas changed the whole atmosphere.

One thing that I still hear a lot about is the 1988 game when Andre Dawson got hit in the face and I charged the mound and got kicked out of the game and suspended. I think every man sitting in that ballpark wanted to do what I did. If anything, that guy sitting in the seats with his family could always relate to me. I was a guy you could trust. I was going to be prepared mentally and physically. They knew how important my family was—you saw my daughter everywhere we went. My wife, she kept score at every single game I pitched at Wrigley. I was in the community a lot. Probably the most special award I've ever been a part of is the Roberto Clemente award, and 99 percent of me winning that award happened in Chicago. We started a foundation where we gave away $100,000 every year, plus any endorsement money I made, in the Chicago area. I bought fifty season tickets to every home Cubs game and gave them away to charity. We gave away ten college scholarships every year. We never talked about it. We wanted to do what we were capable of doing. As these people cheered me or didn't boo me when I didn't perform well, they knew more about me than just the guy that was on the mound. I think all of that has been important to the Cubs fans.

17

BEATING THE STREAK AT WRIGLEY

JOSH PACE, COCOA BEACH, FLORIDA

In late 1997, when I moved to Cocoa Beach, Florida, alone and twenty years old, the Cubs cable broadcasts were one of my few connections to home. The Cubbies provided some relief from the aches of homesickness, and it was in seeking relief in this manner that the true power of Cubs fandom overcame me.

I lived in shabby apartments and drove old cars, but I would rarely miss the three-hour drive to Miami for a Cubs-Marlins series. In the summer of 2003, I named my dog Karros, after a man who I still believe was an inspiring catalyst on a great team.

In 2004, I met my wife, Erin, and she quickly began showing early onset signs of becoming a true Cubs fan. She developed a genuine sense of hope and connection to a team that, considering over ninety years of solid observable evidence, probably should have been avoided.

We went to a few games with mixed results in the win/loss columns. Then, in 2005, "it" began. It was a game just like any other. There was no way we could have known at the time that it was the beginning of a streak that would span over four seasons and include fourteen games that I would attend. The Cubs lost this one and the next thirteen games I attended.

In '05, '06 and '07, I watched them lose in Miami and traveled to Chicago with my lovely bride-to-be to watch them lose there as well. In 2007, I proposed to Erin during a rain delay in the Wrigley Field bleachers, on bended knee in beer and peanut shells, with both of us garbed in Cubs ponchos while a few hundred people took notice and chanted "Say Yes!" She did. The delay ended, and the Cubs lost to the Reds 5–2.

I began to unravel June 2008. While attending all three games of a sweep by the Rays with Erin and my mom, I lost it. I vowed to rename my dog, remove the Cubs license plate from my car and bury all my memorabilia. No one was to speak of the Cubs in my presence. Two months later, I was talking to Mom and Erin about this on the way to see the boys play in Miami. We did not talk about it on the way home. They lost.

On our way off of the Red Line on September 16, 2008, I stopped Erin and said, "You know this is it right?" "Yes," she replied. She understood that my heart could take no more. If the streak were to continue, we would have to stop tempting fate and accept our roles as TV-only viewers. So we were to soak it all in that night as this would likely be our last trip to our favorite place in the world.

During batting practice, one of the Brewers players tossed Erin a ball in the right-field bleachers. It had a goat drawn on it in permanent ink.

After eight innings, the Cubbies led the Brewers 5–3. Kerry Wood took the bump in hopes of a save. Things went bad fast. Kerry gave up three hits and a run. The bases were loaded with two outs in the bottom of the ninth when Prince Fielder dug in about sixty feet from where I stood. He had already hit two home runs that night.

Neither Erin nor I spoke a word as Kerry tossed three balls and Prince took them patiently. Raw emotion swelled as he threw two strikes, but experience caged that wild beast. Kerry took the first sign from Geovany Soto and entered the stretch delivery. Then, there was nothing. The silence continued as a tunnel in my vision opened. I saw Kerry. I saw Prince. I saw an umpire and the batters eye. Then, I heard it—POP!!! It was the distinct sound of a baseball finding its home in a catcher's mitt. Strike three! The crowd and the team went wild as Prince stood frozen in awe of what he later called the best slider he had ever seen.

"Are you crying?" asked the man standing next to me.

"I HOPE THEY DON'T GET BEAT UP"

CLIFF FLOYD, CHICAGO NATIVE, CUBS OUTFIELDER (2007) AND MLB NETWORK ANALYST

As a Chicago kid, I grew up with "Bull" Durham, Jody Davis, Harry Caray and day baseball in the summertime. You couldn't beat that as a kid. As a ballplayer, I was able to appreciate having two baseball teams in the city. With the Cubs, just that tradition of no lights was something special. I did get out to Wrigley as a kid, but not as much as I would have liked because Dad worked nights and slept during the day. There was no chance for Dad to ever say, "Let's go to a night game at Wrigley" because they had no lights. So it was always the White Sox when we went to games at night, but on the weekends, of course, it was great to get out to Wrigley and sit in the bleachers. I sat in the bleachers more than I ever sat behind the dish or down the lines. Out there, it was spectacular to see the fans go from cordial, cool and collected to rowdy rowdies—there was no telling what the heck was going to happen by the sixth inning.

Coming back as a player was nerve-racking. You know all your folks and teachers were watching. I used to caddy in the south suburbs, so all my golfers would come to check me out. I was definitely shaking a bit out there. The fan reception wasn't so bad. I think a lot of the fans in Chi-Town—and nothing against my boy Doug Glanville—but they thought they should have had Cliff Floyd.

It was fun to go out there and showcase in your hometown, especially at Wrigley, where I grew up and watched so much baseball. I had two idols growing up: Harold Baines and Leon Durham. I had a chance to watch them both as a kid, and I was hoping and praying I'd one day get a chance to step on the same fields they played on. I had that chance, so I can't ask for anything more.

Wrigley will always have a fond place in my heart, although the clubhouse definitely needed renovation, so I'm glad that going through now. You could appreciate how long it's been there and the players who had stepped through those doors on the visitor's side and the home side—that was amazing. Then you get on the field and get a chance to be a part of what you witnessed your whole life. You get your family in the stands. You see the grass, and you pretty much lose your spikes in it because the grass is so high. I never knew the dugouts were as low as they were and that you had to stand on the top step to get a glimpse of the whole field. It's those types of things you can't really imagine until you step onto the field and see the stands packed at one o'clock in the afternoon. I was always like, "What the heck, don't you people work?"

When I signed with the Cubs in 2007, to be honest, I had no clue what was going to happen. When it came about, I thought it must have been a joke because so much transpired. I look back on it as both really good and really sad. My Pops passed away in '07. The special part of 2007 that I owe to the organization was how they treated me and how they allowed me to deal with my loss. Because we played day games, I had a chance to pretty much get to the ballpark, play a game and then go home or to the hospital and sit by Pops. You don't get that at most stadiums, where you're playing 7:00 p.m. games. But '07 will always be in my heart. It was a tough year for us. You couldn't have told me we'd get bounced out of the playoffs in the first round by the Arizona Diamondbacks. It was a fun time to play at Wrigley; our fans were crazy excited about our team. They had something to cheer about the whole year.

One game I remember at Wrigley came when I was with the Mets in 2006. The Cubs were up 5–0 at one point. I hit a solo homer in the fifth and a grand slam in the sixth off Sean Marshall. Now, I'd never look in the stands during games, but I always remember looking up and seeing my family cheering for me. I'm thinking to myself, "I hope they don't get beat up after this one because we just turned around a game the Cubs thought they had in the bag." My dad always talked to me about hitting lefties, and I did it that night against Marsh. Believe me, I never let him live that one down when we were teammates.

For me, it goes back to a traditional standpoint. I never got a chance to see Ernie Banks and the other greats that walked that field throughout the years, but I did have the chance to walk across the grass to hit in cage under the right-field bleachers. I'd cross the concourse from the home clubhouse through to the family room, and people would say, "That's Cliff Floyd. What's he doing out here walking with us?" You just don't see those things at the other ballparks. Wrigley can never go away. Renovate it all you want, but I'll always remember the old Wrigley.

19

THE GAME BEYOND THE WALLS

RICH BUHRKE, WRIGLEY FIELD BALLHAWK

I've been a Ballhawk for fifty-three years now—started in 1959. I've had a really, really good time doing it. It's an extension of being a ballplayer, something I always wanted to be. This is as close to being in the Major Leagues as I ever got. When that guy hits a home run and you catch it, for an instant, you're a part of that game. I've been very lucky. I've gotten ten from Santo, eight from Ernie Banks, six from Billy Williams and six from Ryne Sandberg, including the one that won the home run derby at the 1990 All-Star game. I caught Ron Santo's 300th—actually his 299th and 300th. I've collected 5,326 baseballs total if you count all the ballparks that I've been to, and I've got baseballs from thirty-two different ballparks around the country. The Santo one was the big one. The Willie Mays and Henry Aaron catches…those were big, too. My second ever was a grand slam by Ernie Banks. That was huge.

My first ever was a Don Zimmer, believe it or not. The story behind that was Zimmer and Johnny Podres were roommates when he was with the Dodgers, and then Zimmer was traded to the Cubs. It was a 0–2 count on Zimmer, and Podres threw it down the middle thinking nothing was going to happen. Well, Zimmer hit it out of the park. Podres swore at Zimmer all the way around the bases. I got it signed after the game. Many years later, after it started to fade, I took it to a show and went up to Zimmer and told him about it. He said, "Wait a minute, is this the one I hit off Podres? Let me tell you about this." And he told me how he swore at him all the way around the bases and that every time they get together, he still yells at him about it. He said I had to get it signed by Podres. The next year, he came to

Rich Buhrke, one of the original Ballhawks, watches the sky during batting practice. Ballhawks have patrolled Waveland and Sheffield for over fifty years, collecting thousands of baseballs in that time. Their future is in question as renovations might prevent balls from exiting the park on the fly. *Jenkins Imaging.*

Rosemont—thank God, because Podres passed away after that—and I walked up and said, "Don Zimmer told me to have you sign this." He goes, "Oh my God, let me see this" and we talked for a quite some time before he signed it.

As far as the ballpark is concerned, I loved it the way it was. That's why I fell in love with it when I first came out here in 1959. [Rich briefly scurried away at this point in the interview to retrieve a ball that landed on Waveland Avenue.] I probably go in ten to fifteen times a year. Then the rest of the time is spent out here. Wrigley looked a lot different when I first started. Each year, they do something that makes it more difficult for us. The whole reconfiguration of the bleachers really changed everything. We used to be able to see the ball come up from home plate. Now you can't see it until it's on top of you, so you better be ready to move quickly. There's a mystique to this ballpark that you can't get anywhere else. When I first started coming down here, people owned these buildings, not corporations and rooftop owners, and it wasn't the playground that it is today.

We went everywhere with the movie *Ballhawks*. The biggest thrill was doing a question-and-answer at the Hall of Fame in Cooperstown. They took the movie and put it in their archives. So in essence, in a strange sort of way, as a baseball fan, there is no bigger thing that can happen to you. Basically, I'm in the Hall of Fame with my friends because of the movie.

20

MAGICAL SEPTEMBERS

PAT HUGHES, CUBS RADIO PLAY-BY-PLAY MAN, 1996–PRESENT

The 1998 season was very, very special. There was the great home run chase, and that season also included the Kerry Wood twenty-strikeout game, which is the most dominantly pitched game I've ever seen—and I've covered over five thousand big-league games in eighteen seasons with the Cubs. It just came out of nowhere; that's the cool thing about baseball, you just never know when some epic achievement is going to jump up out of nowhere and grab you. People often ask me about the most exciting game I've covered. Certainly, the Kerry Wood twenty-strikeout game is in the top five, but there was also a game in September of that year at Wrigley.

It was September 12, a Saturday. The Cubs won 15–12 over Milwaukee, but there were a lot of other factors that went into it. For one thing, I had my daughter Janell with me—she would have been about nine years old at the time. She came down on the field with me to meet Sammy Sosa. He said, "Hey, little girl. How are you doing?" Sammy, along with Mark McGwire, was the biggest name in baseball at that time. Then Janell spent the entire day right between Ron Santo and me in the Cubs radio booth. In the game, Sammy belted his sixtieth home run. It was the first time a sixtieth homer had ever been hit at Wrigley Field. It was a three-run homer right down the left-field line that led a gigantic comeback.

As I recall, the Cubs were down 10–2 in about the fourth inning of the game before they started that comeback. The Cubs were still down 12–10 going into the bottom of the ninth. It was a wild, wild day at Wrigley with balls jumping out left and right for both clubs. A two-run single by Tyler

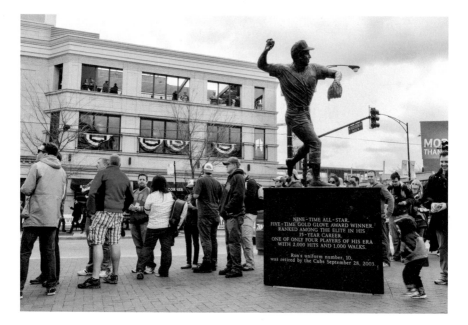

A statue of Cubs legend and Hall of Famer Ron Santo welcomes fans outside Wrigley's Gate D. *Jenkins Imaging*.

Houston tied the game, and then Orlando Merced hit a pinch-hit three-run game-winning home run off the Brewers' Bob Wickman. That was a huge win. It was right in the pennant race. The Cubs were battling both the Mets and, later, the Giants for the wild card. As it turned out, every single win was significant because the Cubs ended the season tied with the Giants. That September 12 game, with my daughter at the park, is a great memory. It just doesn't get any more exciting.

The '98 season was also very special, and so was 2003. Dusty Baker's first year was the closest I've come to covering a World Series. I still hope to get there some day. In 2003, the end of the season was not to be believed. I still remember the Saturday double-header where the Cubs swept the Pirates. They were rained out the day before to leave Houston and the Cubs tied with three games to go. Milwaukee hammered Houston on Friday night, so the Cubs had a half-game lead going into Saturday's old-fashioned double-header. During the first game, we were watching a day game in Houston, where Milwaukee is leading. All of a sudden, the Cubs have a lead in game one of a double-header and you come to this unbelievable realization: if the Cubs win game one and Milwaukee beats

Houston, the Cubs are a game and a half up with two to go, and that means they can clinch the division title by winning the second game of the double-header. That's exactly what happened. The Cubs jumped all over Ryan Vogelsong in the second game, Sosa hit a big home run just to the right of dead center, and the Cubs had about a five-run second inning and led all the way behind Matt Clement.

So, they won the division on Saturday, and on Sunday, Ron Santo's number ten was retired in a special ceremony at Wrigley Field. The whole ballpark was still buzzing the day after the Cubs clinched the title, so it was exciting just to be on the field as master of ceremonies. Add in the fact you have one of the all-time favorites having his number retired, and you couldn't have written a script any more exciting or pleasant than that last week. Those are the things I'll never forget. I love that time of the year. There's really nothing that compares to a pennant race in the world of sports. September ball is just so exciting.

BASEBALL IS MEDICINE, WRIGLEY IS PARADISE

RONNIE "WOO WOO" WICKERS, CUBS UNOFFICIAL NO. 1 CHEERLEADER

My first ballgame, I saw Jackie Robinson play. My grandma had taken me to the ballpark to see the Brooklyn Dodgers. When I come to Wrigley Field, it's just a highway to heaven. I go up the steps and see the field…it's just unexplainable. You see the vines and the clock and the scoreboard and the fans. It's a piece of paradise; it's just magic.

Wrigley Field has done so much for me in terms of learning to be nice and to be yourself. Baseball saved my life back in the day when I had nothing to do. I'm from the South Side, and I came up here to Wrigley and feel altogether different. Now I'm proud of me, proud of my life. I try to give back to the fans and to the neighborhood now. I'm the grandfather out here now because I'm in my seventies. I could be these kids' grandfather, but I'll just try to keep this career going for the love of the game. Baseball is just like a medicine—it's good for people. You come to the ballpark, and it helps you. People can be in a bad mood and come up to Wrigley and feel great about it.

Back in 1949, there were just two bars in this area. It really is amazing how much it's expanded through the years. The fans keep coming back. They look forward to seeing me, taking a picture with me. "Hey Ronnie," they say, "Can you sign my hat?" And it don't cost anything to be nice. It's amazing how the people come up to me; they hear me all over the universe: "Cubs Woo, Cubs Woo, Cubs Woo, Cubs Win. Come on in—me and you and your brother Ronnie Woo." You can't even explain it. It's such

Fans head toward Wrigley's main entrance at Clark and Addison on Opening Day 2013. *Jenkins Imaging.*

a joy to me. Once you see it, you can never forget it. There's never really a bad time at Wrigley. When the Cubs win, by golly, they'll have to call the National Guard, two National Guards from different states. And I'll be right here in it.

22

"I HOPE I DON'T EVER PITCH IN THIS BALLPARK"

FERGUSON JENKINS, CUBS HALL OF FAME PITCHER, 1965–73, 1982–83

In 1965, I was with the Philadelphia Phillies as a September call-up. I pitched in five or six ballgames. Our last road trip was to Chicago. We got there, and it was one of those dreary days in late September. It had rained earlier, and there were maybe only three thousand fans. There were more Andy Frain ushers than there were fans. We ended up playing the game after a forty-five-minute rain delay. I was in the bullpen for the Phillies and got the nod to warm up. I came in the game and got Billy Williams on a fly ball. Then Ron Santo hit a high fly ball to left field. Tony Gonzalez was our left fielder then. He came in and then went back, and the ball landed in the first row. I didn't know Ron Santo at all at the time. He was this chubby little guy who hit the ball up in the air. It looked like an easy out, the second out of the inning, but it was a walk-off home run. I said to myself, "Man, I hope I don't ever pitch in this ballpark." Six weeks later, I was traded from the Phillies to the Cubs. You gotta be very careful what you wish for.

I pitched ten years of my career at Wrigley Field, and I made it a pitcher's ballpark. I never paid much attention to the flags blowing in or out. You can't do anything about the elements; you just have to go out there and play. And with Randy Hundley and so many of the guys we had catching, we had a game plan and we stuck with our game plan. Guys wanted to hit home runs when the wind was blowing out. You can't pitch up at Wrigley Field when it's windy because the ball carries too well. Secondly, I always told the grounds crew to let the grass grow because I wanted to throw my sinkerball

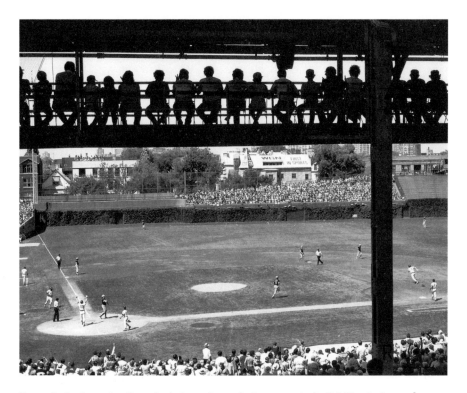

Fans take in the action from the balcony beneath the upper deck. *Bob Horsch photo (www.horschgallery.com)*.

so that Kessinger, Beckert and Santo could make plays on the ball in the infield. We used to have the grass pretty high. Guys would come in and say, "I can't even see my shoes the grass is so high." It was the same thing in the outfield—the ball slows up going into the gap, and instead of an extra-base you're held to a single. We paid attention to the field, too. In the alleys…you see that 368 sign out there to both alleys? No, it's 340 feet—Milt Pappas and I measured it. Pitchers would go, "That's a cheap home run."

And then they got that stupid basket. I probably gave up ten or twelve home runs in that stupid basket. The only reason they changed the dimensions of the field was because people jumped over the wall on Opening Day one year—either '67 or '68. We came back, and all of a sudden the wall was crowned and that basket was there. Billy Williams could jump pretty high, and he had a bunch of balls that should have been doubles or could have been caught but ended up in that basket. Incredible. That's one thing they need to get rid of. Tell Tom Ricketts to get rid of that basket.

I hit quite a few home runs…maybe the wind helped me. They did have that high screen in left field. And the one against Billy Champion—that was the hardest ball I ever hit. He was a fastball pitcher with the Phillies. I hadn't got one step out of the batter's box before it had already hit the high fence. I couldn't hit the ball any harder than that. I just said, "Holy smokes." Guys made mistakes. I was a pitcher who was also a ballplayer. I tried to play as hard as I could, and if I got a chance to get some base hits, I would. If the pitcher made a mistake, I tried to punish him. They'd definitely try to do the same to me. That's their job.

Wrigley Field has a lot of mystique. It's a generation situation where fathers take their sons and daughters and they become Cubs fans. I've met a lot of grandfathers, fathers and sons that come to the ballpark together. Maybe the grandfather saw me pitch, but the grandson never did, and he's telling stories about how this is Fergie Jenkins and how he pitched ten years and had some success. And then Ricketts put the banners up there. You got Sandberg, Dawson, Williams, Banks and myself. Those photographs are like twenty feet tall, so people kind of recognize that. That helps make sure your career doesn't die.

Then they retire your number and fly the flag out there in left field. When an organization retires your number and puts up a flag for you, it makes you pretty damn proud. It was definitely unique to have that happen. It's like Kevin Costner in *Field of Dreams*: you earn your way to get there, and you have to be consistent to stay there. That's what baseball is all about. Wrigley Field is the Field of Dreams.

BEST FRIEND'S WEDDING VERSUS CUBS CLINCHER

MIKE MEADE, CHICAGO

My best friend, Chris, was getting married on September 20, 2008—the day the Cubs had a chance to clinch the division against the Cardinals. The wedding was being held a good half hour away from the ballpark in the suburb of Niles. I was there for the entire ceremony, which was in Greek, so I

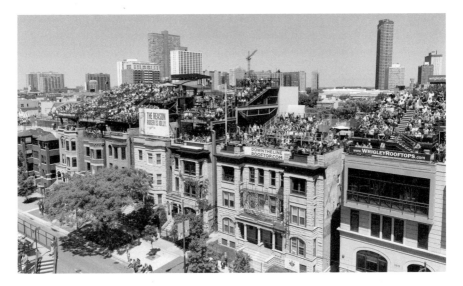

Crowded rooftops have been a common sight over the years. Rooftop owners and the Cubs have had a tenuous relationship but now partner in a revenue-sharing deal that brings a portion of rooftop revenue back to the team. *Dan Campana photo.*

The "Eamus Catuli" sign hanging on a Sheffield Avenue building keeps a running total of years since (from left) the Cubs' last division title, National League pennant and World Series championship. While the phrase's traditional translation is less specific to Chicago's baseball team, online programs interpret the words to mean "Go Cubs." *Dan Campana photo.*

didn't understand a single word of it. The whole time I was there, I going back and forth between watching the wedding and watching the game on my phone. All of a sudden, they say it's the end of the wedding, and I'm like, "It is?!" I looked at my watch and thought, "I can do this."

I said my goodbyes to everybody and said, "See you at the reception." They kind of knew what I was going to do. I got in my car and bolted down there. I was a manager at a rooftop down there, and my parking spot was still available by the Cubby Bear. I ran past Clark and Addison. As I was running, I saw them change it from the seventh to the eighth inning on the scoreboard. I got up to the top of the rooftop and got to see the final five outs of the game. It was crazy. I videotaped everything with my handheld camera.

When I got back to the reception, which was in a suburb even farther away called Kildeer, Chris saw me asked if I had been there the whole time. "I have a confession," I said, and I opened up my suit coat and showed him that I was wearing the Cubs division championship t-shirt. He was a Sox fan, so he didn't appreciate it. But I was like, "Hey man, I'm here." I wore the t-shirt the rest of the night at his wedding.

HISTORIC HOME RUN MADNESS

DAVE LEVENSON, FILMMAKER/WRIGLEY BEER VENDOR

It all started in the fifth inning on September 13, 1998. I had just finished selling a case of beer and was headed back into the seats to sell the next one when Sammy Sosa stepped to the plate. With the home run record chase going on, everyone in the park was standing every time he came to bat. At this point, Sammy had sixty homers, just two behind Mark McGwire. I headed toward the outfield fence area to sell my beer in case he hit one out so I could see all the commotion on Waveland. There were probably four hundred people on the street. To my amazement, Sammy jacked one onto the street. The crowd went berserk, with everyone in a mad scramble for the ball. Thirty seconds later, I saw Moe Mullins—one of the original Ballhawks—standing above the crowd. I'm thinking, "Oh my god. Moe Mullins caught number sixty-one. I've got to get out there and start shooting video for my movie [*Wrigley Field: Beyond the Ivy*.]"

I took my case of beer back to the commissary and told them I was sick and had to leave immediately. I ran out to my car and grabbed the camera, locking my keys inside in the process although I didn't know it right away. With camera in hand, I headed to Moe's van to learn that it was actually another Ballhawk, John Witt, who retrieved number 61. The other guys had ushered him to Moe's van for protection from the mobbing crowd. I stayed out there while John signed autographs, posed for pictures and did interviews. It was fantastic to know that Moe had been part of the excitement of number sixty-one, so I kept my camera trained on him when Sammy came up in the seventh inning and struck out. Two things crossed my mind at that point: 1)

Sammy wasn't likely to bat again, and 2) I had locked my keys in the car. So I walked toward Addison to catch a cab home but quickly changed my mind and headed back to Waveland just in case. I stood there and just shot general footage of the crowd. Many of the people were making faces at the TV news crews on the street. Then a loud roar enveloped the area and everyone on the street started running toward the alley far beyond the left center-field wall—Sosa had just hit number sixty-two onto Waveland!

A giant mob filled the alley, and I could see this mass of people in a pile. I raised my camera above the crowd as high as I could for three or four minutes as people in the pile kept scuffling. As I backed off the crowd, I noticed a guy slowly walking away from the pile surrounded by folks who were either congratulating him or trying to stop him from leaving. Suddenly, he bolted from the group and ran as fast as he could down Waveland and then north on Sheffield. I chased him with about thirty other people all the way to Grace, where he met a police officer who took him away in his police car. This guy had ball number sixty-two! Not too long after that, I started to hear from several people that the guy had stolen the ball from Moe. I got back to the alley to find a bruised and battered Moe being interviewed by all the TV stations. Moe said he had picked up the ball cleanly and taken two steps before being tripped to the ground, starting the pile up with everybody trying to wrestle the ball away from him. While this was happening, I started to piece together interviews about what had happened to Moe. I eventually broke into my own house by throwing a cutting board through a window so I could get my spare keys and a digital tape recorder—all of this while the game is still going on. I got back to Wrigley with Sammy on deck wondering where Moe was and if Sammy could possibly do it again. He didn't, but I continued to do interviews and seek out details of what happened to Moe and number sixty-two. By the next day, the story took off nationally.

THE PEDICAB MAGIC

MATT FURLIN, PEDICABBER

It was 1981 or '82 when I met up with the first pedicabber. Three years later, I bought it from him, and I have been doing this ever since. I got a good deal on it back in the '80s. This bike here is a Taiwan-China bike, and it's hard to say exactly how old it is. Since purchasing it, everything on it has been reworked or replaced. Conservatively speaking, I have well over twenty thousand Chicago street miles on it.

In the mid-'80s, there were five pedicabbers; now there are hundreds. The whole concept of pedicabbing is cooperation, not competition. When there were just five of us, some people didn't know what was going on. Now that people see us all over the place, they get it.

One of the first pedicabbers described us as a loose-knit federation. As for me, I describe us as fly-by-night gypsy cowboys. We're the closest thing you can get to cowboys in an urban setting. There's sunshine and freedom, and you can work as hard and as long as you want. You're outside. You're exercising. You're socializing. If you come home with a little more money than you had at the start of the day, then it was successful day.

There's only a few of the old-timers left, but every year there's a new wave of pedicabbers. And why not? I've always said the best way to spend a summer in Chicago is pedicabbing it. You go to all the street fests and parties, and you're always kind of on the outside looking in, but you're also a part of the whole thing. The beauty of this job is that you never know what's gonna happen—it's the great unknown. You head out there and you never know what you're going to run into or who you're gonna meet. I call

Michael Jette
started playing
the accordion
outside Wrigley in
the early 2000s,
although he's
limited to pregame
performances
because of
restrictions on
street musicians
after night games.
He is part of
what pedicabber
Matt Furlin calls
the fabric of
the Wrigleyville
neighborhood.
David Levenson photo.

it "pedicab magic." That's when I just stop and realize that I would not be here doing these things with these people if not for the pedicab. Those are magic moments.

What a different atmosphere it is when there's excitement going on inside the ballpark. When the Cubs are in the race, the electricity is palpable and everyone is happy. When they're not doing well, people are bummed out. Drunks are our best customers, and happy drunks are even better than sourpuss drunks. We'd sit at the top of the hill by the firehouse, give one ride and then just hang out at the corner by the Cubby Bear. Now it's so congested that there's just no way to be there. It's such a different atmosphere. There is absolutely no normalcy. You throw yourself out into the wind and see where it takes you.

The neighborhood has gotten a lot better; now it's a destination. If the Cubs can ever put together a good package on the field, it will be outstanding. The Cubs are my team. I just love that ballpark. Even after all the changes, it's still so beautiful.

26

ONCE A CUB, ALWAYS A CUB

JIM RIGGLEMAN, CUBS MANAGER, 1995–99

Certainly, Wrigley is a very unique setting. The highs and lows of my experience there would start with the 0–14 start in 1997. Losing fourteen in a row out of the blocks is very demoralizing. At the same time, one year later, the '98 season was one of the most exciting in the history of baseball because of what the Cubs did, what Sammy Sosa did and what Mark McGwire was doing in the same division. They played a 163rd game that year, a playoff game to see who got in the playoffs. That night, everyone was extremely on edge. The crowd was so fired up and so supportive. It was just two teams with great history—the Giants and Cubs—and winner take all. It was just an electric night—probably the most exciting night that I've spent in baseball as a manager. Going from '97, the low, to '98, the high, kind of epitomizes the experiences of Wrigley Field.

While some say the fans don't care, nothing could be further from the truth. It's a huge city, and there's great history in Chicago, so there's the potential to have high attendance. The people are extremely passionate. Anybody who's managed there—and I've talked to other managers who have—they all kind of shake their heads about this perception of the "Lovable Losers" and that everything's OK. No, it's not OK. The fans are on your butt. They are on you, they are questioning you and they're passionate about it. And that's a good thing. That's why in '98, when we got to the playoffs, I was probably more criticized as a manager. And I know some other managers who were in there after me said the same thing when they were on the verge of getting in the playoffs. Fans were saying, "Look, we can get this done. Don't screw this up Mr. Manager."

Fans sitting in the terrace sections, commonly referred to as the grandstand, have varying views of the entire park. Some seats farther back have views obscured by support poles or no sightline of the historic scoreboard. TVs have been added above the terrace seats over the years to provide fans with replays and other game information. *Dan Campana photo*.

When I came back to Wrigley as a coach for the Dodgers and as manager for the Nationals, I was received so warmly. It was really a great feeling that the Cubs fans welcomed me and were extremely positive. Once a Cub, always a Cub. Even many years after '98, there were comments coming from the stands like, "Hey, thanks for '98." I think there is a real loyalty there among Cub fans. If you were a Cub, they hold you in a special place. Chicago in general is everybody's favorite place to go. For a visiting player, you're looking at that schedule to see when you play the Cubs and hoping it's during the warmer weather. It's amazing that the players hold it in such high regard because the facility itself needs work. The batting cages, the clubhouse situation—there was constantly a discussion about what could we do to make this better, but you didn't want to take away from the charm of the place. Yet for a place where the behind-the-scenes stuff was not great, it was almost every player's favorite place to go.

WRIGLEY FROM AFAR

PETER WILHELMSSON, CUBS FAN FROM SWEDEN

I became a Cub fan around 1984 or 1985 when I saw the movie *About Last Night* with Demi Moore and Rob Lowe. In one scene, they are on a roof and look out over something

beautiful—Wrigley Field. After that, I tried to learn more about it and eventually became a huge Cub fan. I've collected many books and DVDs, but I couldn't have done it without the help of Stephanie Leathers and her newsletter in Chicago called "Bleacher Banter." She died three years ago, and I still miss her a lot.

A public notice hangs outside Wrigley in 2013 amid the Cubs' plans to renovate the historic park. *Dan Campana photo.*

I've been to Wrigley a few times, most recently in May 2013 for six games. I really love the Cubs, Wrigley and Chicago. I hope that the politicians learn to give the Cubs some freedom to do what they want. I visited Fenway Park a few years ago and really loved that it was both old and new at the same time. I can't wait for Wrigley to be that way.

28

WRESTLING AND WRIGLEY AND MORGANNA, TOO

COLT CABANA, PROFESSIONAL WRESTLER/CHICAGO-AREA NATIVE

My mom was a Chicago Public School teacher for more than thirty years. Every day, she would come home from school and turn on WGN. She'd be on the couch watching the Cubs. That was her routine. So before I knew it, I would come home, sit on the couch and watch the Cubs with her after school. I remember the first time it hit me about being a Cubs fan—it was at a Doug Collins basketball camp at Concordia College. There was a break, and the Cubs game was on. I remember thinking that I needed to be watching the Cubs game right then because that was my routine. That's when I realized I inherited being a Cubs fan through and through from my mom.

As a youngster, when I was in high school, I'd go into the bleachers a lot because it was such a cheap ticket. My mom would tell me stories about herself as a youngster going to the bleachers when the tickets were two bucks. She'd list off all the players. That's where I learned about the older players. Those kinds of memories, learning that history from my mom, definitely stand out.

There's that place Yesterday on Addison. It's been there forever. I'm a diehard Cubs fan, but wrestling is everything to me. It's my profession…it's what I love and what I grew up with. So before the Internet and before any of this exposure, one of the great things I remember doing as a kid going to Wrigley was going to Yesterday because they had 1970s wrestling magazines for very cheap. I knew that was the place I could learn about wrestling, and I'll always tie that in with going to Wrigley. When we'd be walking to the car, I'd always ask my mom to stop in there for a second. I'd gather up whatever

money I had, or my dad would buy me a couple magazines. It wasn't like they were the most expensive things in the world, but to me, a kid growing up in the '80s, finding those 1970s magazines with Billy Graham or Bruno Sammartino on the cover was like gold.

I was lucky enough to see Morganna the Kissing Bandit kiss Mark Grace. You have to remember, I was just going through puberty, and my hormones were kicking. To see that was something spectacular. She was unbelievable.

Whenever you go to games at Wrigley, there's always that smell, which I didn't realize as a kid was Old Style beer. You see all these youngsters around you drinking the beer. I think I had an idea of what getting drunk was because of going to Cubs games. My thing was always to find the drunkest guy and try to get him to run on the field for my own enjoyment.

When I was sixteen years old, I won "Play Catch with a Cub." I remember I filled out the sheet at Sportmart and then the woman called me to say I had won. I was like, "Oh, sweet." She said, "How are you not excited about this?" Then I realized, "Wow, I guess this is pretty crazy." Only five people won. This was while Sammy Sosa was at his hottest, and Mark Grace and a couple other guys were still around. There were all these spectacular Cubs players, and I remember I was the one who drew Scott Servais. A four-year-old girl won the chance to play catch with Sosa, and I was so bitter about it. I was like, "She won't appreciate it." So I got to go on the field and play catch (I was playing high school ball at the time) with Scott Servais. He walked me around, and I got a full scope of the field and got to touch the ivy. It was really cool to do that. It's just funny—I wasn't bummed out or anything, but I was like, "Aw man, it's Scott Servais."

These days, I'm at Wrigley a lot because of my best friend, CM Punk. We both started in Chicago on Irving Park, just two hungry guys trying to be wrestlers. He's friends with the players and gets invited into the dugout to trade merchandise. He has almost become the new Belushi, if you will.

Whenever we're home (we're both on the road so much), he's always saying, "Let's go to a Cubs game!" Before you know it, you're at a Cubs game three days a week. It's cool for me because they treat him so well and give him such nice tickets. For years, I was sitting way up in the upper deck or in the bleachers, and to be able to go whenever you want and sit behind the plate is spectacular. In 2012, he sang "Take Me Out to the Ball Game" a couple days after my birthday. It got cut off on TV, but after the song, he said, "Happy Birthday, Colt Cabana." That was one of the coolest moments of my life. There was a whole group of us there to see him sing. I had been there when he threw out the first pitch a couple times, but that was his first time singing the stretch. Of course, I was there to support him.

UP CLOSE WITH THE MONSTERS
OF THE MIDWAY

RON NELSON, FORMER CHICAGO BEARS PHOTOGRAPHER AND AUTHOR OF *PRO FOOTBALL AT WRIGLEY FIELD*

In 1960, I went to a Bears game at Wrigley. I got down in the front row of the left-field bleachers and took pictures of the end zone. I went home and printed them up, and a few days later, I went to the Bears' office and said, "I want to show you some of my pictures." They sent me in to see Rudy Custer, George Halas's right-hand man. He took care of everything. I showed him these eight-by-ten prints, and he's like, "Wow! Where are these from?" I told him the left-field seats, and he said, "You got to be kidding me. What are you doing next Sunday?" I told him I'd probably be out in the bleachers. He reached in his desk and handed me pass. "No, meet me at noon at the fifty-yard line. I got some work for you." I just about flipped. That's how I got started.

After the last game of the year, I brought my pictures into Custer. He said he couldn't pay me but that he would give me two passes for the sidelines so I could bring an assistant or a friend. He would tell me what to shoot, and then he'd let the PR department distribute the photos to the papers. He also said he'd refer me to anyone who called about photographs. That worked out pretty good—I got a bunch of stuff in some newspapers and magazines.

Halas being Halas, he didn't want anybody on his sideline. A couple times, I worked my way behind the end zone and, when nobody was looking, snuck up by the Bears bench and shot for a few minutes until they chased me away. "Get out of here," they'd say to me. I'd say, "I'm working for the Bears." They'd say, "Halas doesn't want anyone over here."

One day I was picking up my passes at the gate on Waveland and this guy comes up to me. He says, "I gotta get some tickets—you got any extra

tickets?" I said I didn't and looked up to see that it was Sid Luckman. Another time, an old friend of mine, Dave Maenza, a longtime Chicago photographer, was down there during the game not really sure what he was doing. He was in the end zone when an extra point fell short, and he picked up the ball and threw it to the guys in the seats. Everybody cheered because he threw the ball in the crowd, and we were just laughing. About three days later, he calls me up and says, "Nelson, I just got a letter from Halas. He said I owe him thirty-five dollars for that ball I threw in the seats."

I saw Johnny Unitas the first time he played there. I also saw Gale Sayers, Mike Ditka, Johnny Morris and all the great guys who ended up on the 1963 championship team. It was really a lot of fun to shoot there. I did it for about ten years, and when they moved to Soldier Field, that was it for me. I ended up with about three thousand negatives. A friend eventually talked me into doing the book *Pro Football at Wrigley Field*. It turned out pretty well.

AN UNEXPECTED CALL TO THE MOUND

BRIAN CORBIN, CREATOR OF "BULLPEN BRIAN" CUBS BLOG

In September 2012, I registered to attend the Cubs first social media promotion at Wrigley as part of their game against the Pirates. Part of the event included raffles where participants could win Cubs memorabilia, among other things, and a grand prize of throwing out that night's ceremonial first pitch. Lo and behold, my name was drawn last, and amazingly, I hit the jackpot. When I boarded the Red Line earlier that afternoon to head to the Friendly Confines, I hardly anticipated anything like the chance to throw out the first pitch. I also couldn't have anticipated that I'd make history in the process.

Stormy weather had delayed the start of the game by more than three hours by the time I strolled to the mound at 10:28 p.m. I doffed my cap to the sparse crowd that remained and then delivered a low strike to Cubs rookie reliever Jaye Chapman. With that toss, I had officially thrown the latest ceremonial first pitch in Wrigley Field's history. Shortly after I toed the rubber for my record-setting pitch, Cubs left-hander Travis Wood officially delivered the latest first pitch ever at Wrigley Field at 10:42 p.m.

The Pirates went on to defeat the Cubs 3–0 in a game that ended at 1:42 a.m. The outcome aside, throwing out the first pitch was as thrilling as I imagined it would be, as was the chance to step on the field where my favorite players play the game I so dearly love. My memories of that night's game are certain to last a lifetime.

A RITE OF PASSAGE

CHET COPPOCK, CHICAGO SPORTS BROADCASTING LEGEND

What makes Wrigley so special? How can I put this in secular or non-secular terms? It's almost like a rite of passage. You're almost required by law as a parent to take your kids to certain places: Disneyworld, Disneyland, Wrigley Field.

I remember the first time my dad took me to Wrigley. I don't remember the score, but it was against the Milwaukee Braves. There was Henry Aaron, Eddie Mathews and, of course, Ernie Banks for the Cubs. I was in awe, completely overwhelmed by this. By the time I was fifteen or sixteen, I'd hitchhike into Wilmette, eventually catch the "L" and get off at Addison. You could get by with five bucks in your pocket and live like a king. Hot dogs were about a quarter, pop was about a quarter and little bags of popcorn were about fifteen cents.

One game that stands out was Opening Day 1969, when Ernie Banks homered in his first two at bats against the Phillies on a bitterly cold day with winds off the lack. Don Money homered for Philadelphia in extra innings to give the Phils a lead. Then Willie Smith came up for the Cubs and put one into the right-field bleachers in the bottom of the tenth for the win. I swear the call by Jack Brickhouse was so guttural, so full of energy. It was an absolutely unforgettable moment. That was what propelled the Cubs into this tremendous run that really reached its apex on August 19 when Kenny Holtzman tossed a no-hitter against the Braves. At that time, I was all of twenty-one years old, and WFLD sends me over to interview Holtzman after the game was over. After years of going to games as a fan, one day you wake

up and you're standing on the field as a reporter interviewing Holtzman after he throws a no-hitter. I also was there on May 15, 1960, for Don Cardwell's no-hitter in the second game of a double-header. By Cubs standards in those days, there really was a pretty good crowd in the house—about twenty-five thousand. We're talking about a time when the Cubs rarely opened up the upper deck. Stop and think about that. In 1972, I was living near the park when Burt Hooton had a no-hitter going into the seventh. I went over to the stadium to buy a bleacher ticket because I wanted to say I was there for his no-hitter. Here I am in my early twenties and I had already been to three Cubs no-hitters.

However, my greatest memories of Wrigley are football memories of the past. Wrigley Field will always be the home of the Chicago Bears. Those games were a mass of human flesh violating every fire code in the city. The Bears under George Halas set the field from the left-field wall to the first-base line, compared to when Illinois and Northwestern played from third to right field. Oh, it was as snug as could be. The end zone was only eight yards from the first-base dugout. When you got down inside the five-yard line, you really couldn't pass the ball to the left side of the end zone. I saw guys catch passes and go flying into that brick wall by first base. The end zone in left field was only about a foot away from the wall. It was almost like playing football by UFC rules, but that only added to the charm of seeing Vince Lombardi, Johnny Unitas, Jim Brown and the incredible cast of football characters who came to Wrigley.

The ballpark has this magnetic effect on people. It's something other clubs can only dream about. When your place of business is so engaging, parents feel like it's almost an obligation to take their kids there. In the mid-1990s, while working in New York, we came back for our annual spring vacation. I took my then-six-year-old Tyler to the park. We went to the Friendly Confines Café down the right-field line, and that didn't knock him out at all. But when we went on the field during batting practice, his eyes were as big as saucers.

Tyler and I were together in the front row of the left-field bleachers for Game 6 of the 2003 NLCS. With one out in the eighth, I turned to my son and said, "Do you realize these clowns are actually going to go to the World Series in my lifetime?" He said, "Well Dad, there's still five outs to go." I said, "Oh, come on. Look who's on the mound. Prior is going to take this thing to the wire even if he throws 140 pitches." Then there was the Bartman situation. I remember leaving that night and the crowd, even with the 1 percent who were just hostile beyond words, being just kind of indifferent. I was really taken aback. They were like, "Hey, there's Game

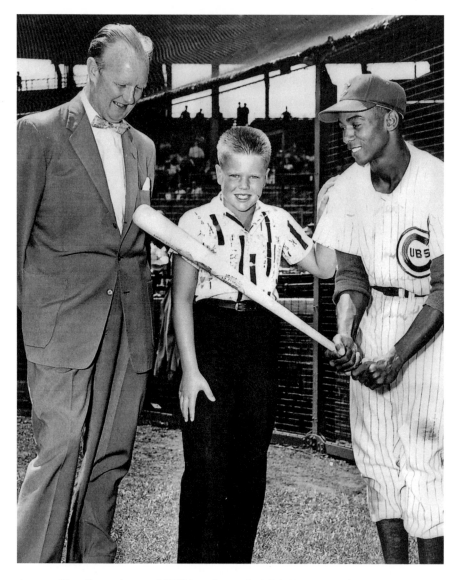

A young Chet Coppock meets WGN broadcaster Jack Brickhouse and Cubs legend Ernie Banks at Wrigley Field in 1958. *Chet Coppock photo.*

7 tomorrow night. Let's go to the bar and forget this almost unbearable atrocity we just watched."

I happened to be in Vegas the next day on business, so I watched Game 7 on the tube. When it became apparent that the Marlins were going to win, I didn't feel any sorrow or great remorse. Hey, it's just the way it's going to be. I honestly believe that they're not meant to win a World Series in my lifetime.

FIFTEEN YEARS OF WRIGLEY VISITS BUT FIRST TIME INSIDE

BOB DAMERON, CINCINNATI REDS FAN

We've been coming to Chicago two or three times a year for probably fifteen years. This year, we decided to follow the Reds to Chicago. I wanted to see Wrigley before they make the changes. Years ago, we came to town for the Taste of Chicago. Many people we know in Cincinnati told us we had to go see Wrigley even if the Cubs weren't playing. So we came over here and went to Cubby Bear and Sports Corner. After that, we decided that we wanted to come back to Wrigley every time we were in town. So, we've been coming here to Wrigley for fifteen years, but this year (2013) was my first time in the park because they were always on the road.

I actually got to go to Crosley Field in Cincinnati before they tore it down and built Riverfront Stadium. Now we have the Great American Ballpark, our third stadium, while the Cubs have had this one. Everybody I talked to said I had to see Wrigley because it's an old-school type stadium. It really is—you're so close to the players. I'm impressed. I like it. The ivy wall and the rooftops were things I wanted to see in person after seeing them on TV. Actually, I wanted to see the lack of technology, and I don't mean that in a bad way. This is old-school. They need to come here and experience everything that goes on around the ballpark. In Cincinnati, the ballpark and the football stadium are both downtown. They're just starting to develop around there. We don't have things like the Captain Morgan Club or the bars and restaurants. They could take a lesson on how things are done here.

In an effort to add entertainment options around the park, the Captain Morgan Club was opened as a place for fans with or without tickets to go during the season. *Jenkins Imaging*.

ONE GIANT LEAP:
A WRIGLEY FIELD SKI JUMP

This 1944 ski season proves to be the year without snow in the Central United States. The hills and slopes of this area are more "undressed" this season than during any one of the past twelve years. Competitive activities have been held to a minimum beyond the ordinary curtailments anticipated because of wartime restrictions.

On January 23rd the Norge Ski Club of Chicago held a ski-jumping contest and ski demonstration at Wrigley Field. The hill was, of course, artificial and the "snow" was of the shaved ice variety. Sgt. Torger Tokle of Camp Hale, Colo., took top class A honors in that event of synthetic ski jumping when Lieut. Walter Bietila of the Navy spoiled his chances of a sure cop with a spill after outjumping the entire field. The crowd of 7,000 people was far below the expected attendance. Cause for the poor attendance is attributed generally to the $2.20 and $3.30 price tags on the better seats; apparently war charities were not sufficient cause to get Chicago ski fans in line for that price seats.

Admissions for the second meet on January 30th were reduced with somewhat better results. A surprisingly large number of skiers in service were able to obtain leaves to attend the events. (Arthur Barth, "News from the World of Ski Sport: Central," *Ski Illustrated, Volume 8, Number 4, March 1944*)

34

A FAMILY HISTORY LESSON

TIM KURKJIAN, ESPN BASEBALL ANALYST

I went to the first night game there, which really wasn't the first night because it got rained out. It was such an exciting experience to see a game in that ballpark at night. Even though it rained like I've never seen before in my life—maybe someone upstairs was trying to tell us this was a bad idea, that we shouldn't put lights up at Wrigley—it was an unforgettable experience. Phil Bradley hit a home run early in that game that went about nine hundred feet because the wind got it. Rick Sutcliffe started that game—now I work with him at ESPN. That was one of those nights when you thought about how long they've playing just day games at Wrigley, back to the days of Hack Wilson and well before then. Even though it was progress and we were kind of sad to see it happen, to be at something historic like that was pretty cool.

On a more personal level, I took my children and my wife to Wrigley right before the All-Star game at U.S. Cellular Field in Chicago years ago. My wife is no great baseball fan, believe me, but she was absolutely dazzled being inside Wrigley Field. When I pointed out that the scoreboard is hand operated, she was completely taken. She's a history lover, and she really understood the history of where we were sitting at that point. She looked at the outfield wall and said, "Is that ivy growing on the outfield wall?" I explained to her a little bit of the history of the ivy at Wrigley Field, and she very naively asked me, "Do other stadiums have ivy on the outfield walls?" And I said, "No, honey. This is it." I think she really got a kick out of that. My wife is really one of the smartest people in the world, but she's not a

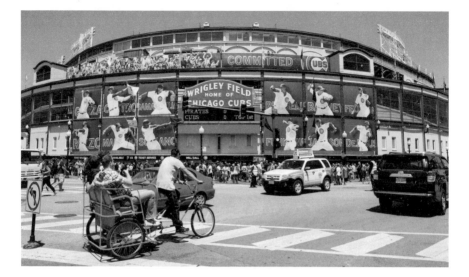

Traffic passes through the intersection of Addison and Clark as fans continue to arrive after the first pitch. *Dan Campana photo.*

baseball fan. Her naiveté on the whole thing…I thought it was really cool that she was learning stuff about Wrigley as she sat there. It made for a truly enjoyable night for her and our children.

It was great that the kids were there also, because as we try to look at the history of baseball, our kids have only been to some of the new ballparks that we see these days. They've been to Seattle or San Francisco for some great new ballpark experiences, but then they got to go back in time and go to Wrigley. Even though they were young at the time, I think even they could appreciate how old it was. After seeing everything new, I think they enjoyed something from the past.

With any old ballpark, the first thing I think of is who played there a century ago and what that must have been like. I'll use Hack Wilson again. This stubby little five-foot-six guy who knocked in 191 runs one year played right here. That's the stuff that always gets me. From an aesthetic point of view, no matter how many times I go there, I look at those rooftops across the street and I just imagine a ball landing on a rooftop that is close enough to the ballpark to actually be in play in some way. I just find that remarkable. And the scoreboard…it's such an anachronism to see an old-time scoreboard in 2013. It takes me back to the early 1900s.

FOOTBALL RETURNS TO WRIGLEY

NICK HAYWARD, PEORIA, ILLINOIS

It was just so different. I had walked down Sheffield Avenue to Wrigley Field many times in the past, but never on a cold November morning, never while wearing my Fighting Illini winter gear and never while toting tortilla chips, queso and a slow cooker. But it was hard to find anything normal about the Illinois-Northwestern football game at Wrigley Field on November 20, 2010.

For one day, Wrigley had become the mecca of college football. ESPN's *College Gameday* broadcasted from the McDonalds's parking lot on Clark Street, with Mike Ditka—a veteran of many football games at Wrigley—joining Chris Fowler, Lee Corso and Kirk Herbstreit on the set. A short walk away, the Heisman Trophy was on display, with security personnel ensuring the picture-snapping crowd kept its distance. Who would have ever guessed the Heisman Trophy would appear at Wrigley Field before a World Series trophy?

Fans clad in orange and purple surrounded the ballpark all day. I tailgated at my friend's apartment on Waveland Avenue across from the left-field foul pole. The Marching Illini, noticing a throng of orange at our tailgate, performed an impromptu concert for us in the early afternoon. Some friends of mine donned orange T-shirts with a picture of former governor Rod Blagojevich on the front and "Northwestern Class of '79" on the back. A *Chicago Tribune* reporter snapped a picture of the shirt and posted it on Twitter, calling it the best "in your face" T-shirt of the day.

As strange as the scene was outside of Wrigley, the scene inside was even more jarring. The pairings on the scoreboard read Michigan-Wisconsin and

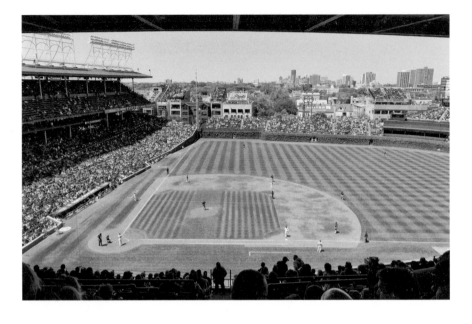

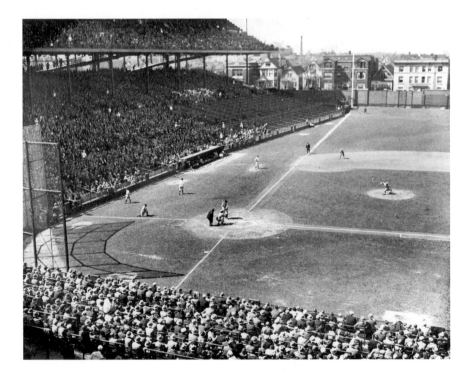

Iowa–Ohio State. The National League team flags above the scoreboard had been replaced by Northwestern flags. Other purple flags flew atop each foul pole. But the most unfathomable sight was a gridiron laid out on Wrigley's grass stretching from the third-base dugout to the right-field wall, with the goal post at the east end zone erected at the top of the wall near the basket.

My seat for the game was in the front row of the upper deck along the first-base line even with the twenty-yard line, or what typically is short right field. To my left, I saw the bells of the Marching Illini tubas and fans dressed in orange above the Cubs bullpen. To my right, I saw the Northwestern students cheering from the right-field bleachers. And in front of me I watched a Big Ten version of "losers walk" as both offenses drove toward the west end zone, the east end zone having been declared unsafe for being too close to the right-field wall.

As I watched Mikel Leshoure run into the record book during Illinois' 48–27 win over Northwestern, I couldn't help but think about the time when Wrigley was both a ballpark and a football field. The Chicago Bears played at Wrigley Field from 1921 to 1970, and I found myself wondering what it would have been like to see Red Grange, Gale Sayers and Dick Butkus play on this field. Football at Wrigley had been something from the distant past, but for one day, a treasured piece of Chicago sports history was resurrected.

Opposite, top: Over the years, this view from the upper deck along the first-base line could also have doubled as an end-zone seat for a Chicago Bears game from 1920 to 1970 or, in 2010, a sideline view when Northwestern University and University of Illinois played a Big Ten football game. *Dan Campana photo.*

Opposite, bottom: A view from the upper deck on the first-base side. The upper deck was constructed in 1927–28. This photo predates the construction of the bleachers in 1937. *National Baseball Hall of Fame Library, Cooperstown, NY.*

A LATE NIGHT WITH PEARL JAM

LOU SANTANGELO, CUBS FAN/CONCERTGOER

I'm a lifelong Cubs fan, thanks to my parents. I grew up watching them for many years and walked to many games, especially when I lived in the area near Southport and Lakeview. Then they started having these concerts (and I'm a big concert guy) beginning in 2005.

The first one I went to was Elton John and Billy Joel in 2007, which was pretty good. I think we ended up paying $120 a ticket or so for seats on the third-base line. They basically put the stage in center field, with this huge sound system, and the sound was pretty good there. There's really not a bad seat in the house, because you're not really going back, you're going up. I saw Dave Matthews Band a few years after that. I bought the seats online and ended up sitting way up in the back, second to the last row in Section 500. I saw Roger Waters play *The Wall*, and it was frickin' awesome. It was this big extravaganza with all the lighting equipment and special effects and all the crazy *Wall* stuff. They had this big blow-up pig flying around Wrigley Field. They had the guy from *The Wall*, the teacher, as a giant puppet out there. It was kind of amazing to see how they did it without destroying the field.

Of course, the most recent one was Pearl Jam. When I saw they were playing at Wrigley, I said, "I don't care who I'm going with or how much it costs, I'm going." The tickets sold out in like four minutes or something, so I ended up going online and biting the bullet to buy two tickets for way more than what they should have been—probably $200 a ticket—but I had to go no matter what. Eddie Vedder is a Cubs fan, so I figured he was going to put on a good show. They started playing about 8:30 p.m. and opened up with

"Release." They played about five or six other songs, and in between, Eddie would mention there was this big storm coming in and that they would probably have a delay. He said, "We're gonna rock out here 'til 2:30 in the morning if we have to, so don't go anywhere." He was basically trying to chill out the crowd because there was going to be a rain delay.

Sure enough, about forty-five minutes later, they literally cleared the entire field and put them in the concourse. I was lucky. Sitting toward the front of the upper deck in Section 400, they didn't kick us out, and we were actually covered. It was kind of awesome just to sit up there and have a couple of beers watching everything happen. The storm didn't come for about another hour and a half. It came through, and it poured for forty-five minutes or so before they let everyone back on the field. It was about a two- to two-and-a-half-hour delay. And sure enough, as promised, Pearl Jam came back out. The very first song they played was that Cubs song, "(Someday We'll Go) All the Way." That kind of got the crowd going, and they just rocked it out until about 2:15 or 2:30 in the morning. I could tell the majority of people stayed. I'd definitely do it again even though I had to pay way more than I would have liked.

It seems like anytime a band plays at Wrigley, there's an awesome energy. They still have their beer vendors and hot dogs, and they sell everything they normally do. The only difference is that you're seeing a concert instead of the Cubs. Before Pearl Jam, we hung out at Murphy's like we were going to a Cubs game. A concert at Wrigley is something you've never seen before. Usually you go out there for a game and see the nice green grass field. For a concert, there's this giant stage and these big screens and all this metal…you kinda have to stop and think about what is and where you are. It blows my mind the way they transform it.

WRONG RADIO STATION LEADS TO NIGHT WITH MCCARTNEY

BOB SCHUMAN, LOVES PARK, ILLINOIS

I was born in the early '60s. My older brothers were into the Beatles quite a bit, so I was interested in the Beatles through them and remember growing up with *Help!* and *Hard Day's Night*. One day I was driving to work and happened to have the wrong radio station on. They were talking about Paul McCartney giving a concert at Wrigley Field. I was like, "How did I not know about this?" I thought it would be kind of neat to go since I hadn't seen since him in '89 at Indianapolis, the Flowers in the Dirt Tour, where he started singing Beatles songs again.

A lot of the tickets had already sold out, but I found out they still had some available. I couldn't believe I was going to drop this kind of money, but it was kind of my son's birthday present, since the concert we went to was on August 1, 2011. This was a once-in-a-lifetime thing—Paul McCartney's not getting any younger. He's a legend. And through me, my kids had an appreciation for the Beatles. They knew who McCartney was, but I think that when they get older, they'll realize it was bigger than they even imagined at the time. This would be my kids' first concert, so I figured what could be better than Paul McCartney at Wrigley Field. So we bought four tickets.

I remember it was a real hot day—I mean really hot. We got there early and stood outside waiting to be let in. You could hear McCartney playing some sound checks. I turned to my daughter and son and said, "Hey, that's Paul McCartney, former Beatle, right behind this wall doing sound checks." He'd sing a little bit of this song and little bit of that song. It just kind of built up the energy, and I couldn't wait to get in there to hear more.

Our seats were in the middle price range in aisle 231. We were pretty happy with where we were. The way they had the stage set up, no matter where you sat, you had a pretty good view. I don't think you really could have a bad seat. I was looking at those people in the front row, and with what those tickets were going for I wondered what they did for a living. Wrigley is a great venue for a baseball game; it's even a great venue, at times, for concerts, especially when you have a big name like Paul McCartney. When he hit the stage, the electricity that went through the whole place was tremendous. His energy, given his age and the heat, was just phenomenal. He's such a performer.

I'm glad I happened to be listening to the wrong radio station when I was to find out about this concert, and I'm glad I was able to get four tickets at the last minute to take my kids to see him. The opportunity to see Paul McCartney in concert at Wrigley was a great experience, with his catalog of music and the history of ballpark…Babe Ruth calling his shot and everything else. It's really a family venue. You go for a baseball game, and you've got kids, parents and even grandparents. As I was looking around the audience at the McCartney concert, I was amazed to see children there—four, five and six years old—who probably had no idea who he was. And then you had older fans who had grown up with him since his days as a Beatle. You had the entire spectrum of age ranges there, just like at a baseball game.

STRUGGLES OF A SEASON TICKET HOLDER

MARCIA COLTON, DEERFIELD, ILLINOIS

A girlfriend of mine and I—we were both teachers—spent our summers at Wrigley after college when I was twenty-two or twenty-three. I think bleacher tickets were fifty cents, and you could park anywhere on the street. I think they had Ladies' Day back then, and we got in for free or maybe for a dollar. I could tell you who played every day—maybe not the lineup, but those were the days of Ernie Banks, Billy Williams, Ron Santo and Fergie Jenkins. That was when you could pretty much sit anywhere and go down to talk with the players. Fergie gave us a ball once.

I've been a fan for all these years, from '69 into the '70s and then a friend of mine had season tickets in the '80s. We went to a lot of games and usually sat behind third base. I've seen many, many third basemen. That position has changed over so many times. A few years ago, I joined a season ticket group. Coincidentally, someone where I work asked if I wanted to take over her spot in her group as a season ticket holder, and now I've been one for about seven years. Our seats are covered in the Terrace Reserved, so that's helpful when it snows or rains.

I'm taken by Wrigley Field. I like the ivy and the whole closeness of it all. It feels like an intimate setting where no matter where you sit, you can see. A few years ago, we went to Boston and Fenway Park to see the Green Monster, and we were not impressed at all. Wrigley Field is so much prettier because of the fact that it has that neighborhood feeling.

All the games I've seen there are special. If they win, you sing. If they lose, you go home disgusted. I love singing "Go, Cubs, Go!" at the end if we

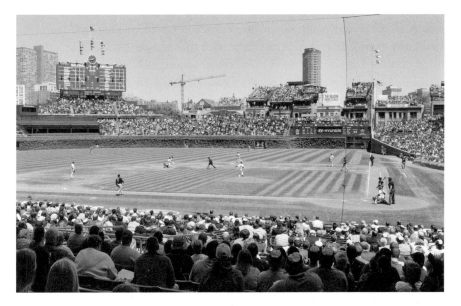

While the field view hasn't changed much over the years, the right-field video screen and see-through screen door were added to enhance the experience of fans both in and out of the park. *Dan Campana photo.*

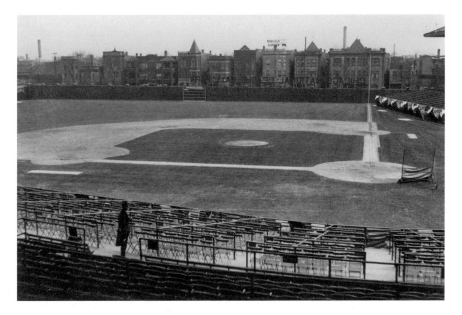

Wrigley's grandstands offered a clear view of the field before the upper deck was built. The grandstand area did not have assigned seating for many years. *National Baseball Hall of Fame Library, Cooperstown, NY.*

win. I do remember seeing a Cubs–White Sox game in 2007 where Derrek Lee hit a grand slam in the eighth inning to beat the White Sox. We had tickets on my birthday in April, and my husband had them put up "Happy Birthday" for me on the scoreboard. I didn't know it, but I happened to look up while they were putting all the welcomes, birthdays and anniversaries up there. All of a sudden, I see my name up there. That was very special. I don't know if he was a fan or not, but I definitely turned him into a Cubs fan.

I have thought about giving up the tickets because it just seems like it's going to take so long for them to get a team in place. It's almost like going to see the Iowa Cubs. You're paying for a Major League ticket to see a minor league club. Now I have to wait a long time because they're signing fifteen-year-olds. Truthfully, it's a very young crowd with a lot of bars, so we don't spend a lot of time in the neighborhood. I think the fans keep getting younger as I keep getting older. There's a lot more drinkers now—you know, one beer after another. Some customers go to Wrigley to drink; I go there for the game. Then there's the standard fans who keep coming and have had season tickets forever, handed down through the family. A lot of people around us sell these seats now, so we don't see the same people. Even the people I share the tickets with—there's another two seats—they sell their tickets, too. I'm the only one in the group still going.

During the week, we take the train because you can't park anywhere unless you pay. On weekends, we drive. We have a certain street where we park—I don't want to give it away, but it's just a few blocks from the ballpark.

So yes, we still go to quite a few games. Once I'm there, I love it. I just love baseball. It's what keeps me coming back. I'm a diehard Cubs fan. And because no one wants my tickets unless they're free, I can't give them away, and my husband and I just keep going. We've come too far to give up.

HELPLESSLY, HOPELESSLY A CUBS FAN

MIKE FOSTER, CUBS FAN/AUTHOR

Y ou never forget your first time.

My first visit to Wrigley Field happened during midsummer 1983. Bill Knight, my editor at the *Prairie Sun*, a lively free Midwestern newspaper covering politics, music and so on, had been amazed to learn that I had never been to a game in the Friendly Confines.

Guilty as charged. My dad, Claude, taught me to love reading and jazz, but he wasn't the kind of father to go out and throw a baseball with you. So one fine, hot Saturday, Bill procured tickets for five: me; my wife, Jo, who is a longtime fan of her hometown team, the Milwaukee Braves; and my erstwhile Illinois Central College journalism student Jeff Putnam and his wife, Janice. We loaded into my Dodge Aspen station wagon and set off from Metamora, Illinois, to Wrigleyville. I found a tight parking place on Irving Park, and we hiked over to the ball game.

Our seats were on the first-base side, about twenty rows up. A balmy breeze blew in from the west. The sky glowed bright blue with puffy clouds straight out of a Maxfield Parrish painting. "Beer man! Five!" Bill shouted, and for the first time I witnessed the honest chain of money going down the row one way and Old Styles coming back down the other. "Hot dog man! Five!" Bill called out again, and again the dollars went one way and the dogs came back the other. And right then and there, I decided that, like Paris and Oxford, Wrigley Field was a place I wanted to return to soon and often. And that was before the Frosty Malts. Heck, the Cubs may have even won that game.

By 1984, I was helplessly and hopelessly hooked. We'd been at the Peoria Bergner's store before it opened on the day single-game tickets first went on sale, speed-walked to the Ticketmaster outlet and bought tickets for four games for us and our two daughters, Martha and Megan. I went to three more games with buddies.

What a summer that was. No bad seats, no bad weather. Behind MVP Ryne Sandberg and Cy Young–winner Rick Sutcliffe, the Cubs went 96–65 and finished in first place. The girls learned to know and love the Cubs, even relief pitcher Lee Smith. This was the year! Until it wasn't. A routine grounder skipped through Leon Durham's legs in Game 5 of the playoffs against the Padres. "Never mind," we said. "Next year for sure."

That was thirty years ago. For our sins, we would return many times. The ticket prices and beer prices steadily increased, street parking became impossible and the Cubs slowly declined. But memories rich as rubies remain. We were there when Padres pitcher Eric Show beaned Andre Dawson, who'd homered off him in the first inning. Dawson went down like a dead man. An angry howl came from the stands while a Niagara of beer descended on the San Diego outfielders. After seconds that seemed minutes, Dawson got up and woozily charged the mound while Rick Sutcliff led an enraged dugout full of Cubs out to the mound on a vengeful vendetta.

For a while, I did Opening Day games with Knight and others from the *Journal Star* newsroom. No matter how many layers I wore, I froze from the feet up, a Cubscicle, drinking a beer that got steadily colder as we did. For several years, I saw Opening Day from the bleachers, standing along the fence in the left-field bleachers with the partying Wisconsin Cheeseheads.

I was in the bleachers on Opening Day the year after Harry died. We didn't see the phalanx of bagpipers massed on Waveland right behind us. When they swirled in with "Amazing Grace," there were no dry eyes in Wrigley.

Broken vertebrae and a hip replacement slowed me down over the last decade. For all its charms, Wrigley isn't a handicapped hobbler's best friend. Jo and I took in our last Friendly Confines game in 2011, but the next generation is on its way. My younger daughter, Megan, and her husband, Frank, took their daughters, Madeleine and Emma, to Wrigley for the first time this year—and the Cubs won. So hope springs eternal. Next year for sure!

THE TRIFECTA IS A FAMILY THING

CLAY GUIDA, UFC FIGHTER

I've been going to Cubs games for as long as I can remember. I always try to get a handful of games in depending on training and traveling. There's nothing better than going to the games and kicking back and enjoying it with the boys or the family. I grew up playing baseball. It's still one of my favorite sports to this day. Wrigley's just a special place to be.

The first time the trifecta happened was the summer of '98, when Sammy Sosa and Mark McGwire were having an epic home run tear. My brother Jason and I got to see Sammy hit three home runs in the same game—his twenty-second, twenty-third and twenty-fourth of the season. It was pretty awesome—it's not too often you get to see anyone hit three home runs in the same game, let alone Sammy Sosa, who was one of my favorite players. It was such a legendary, magical season to see baseball brought back to the forefront. We were in left field for the game, just down the left-field bricks. We got to see the home runs within fifty to sixty feet. It was pretty sweet.

It happened again during the 2013 season, which was also another family experience. My brother and I were there again. This time we brought my dad down there as well as our daughters. My niece Taylor, my brother's daughter and my daughter Gia came along with their Grandpa Chuck. We got to see Dioner Navarro crack three home runs against the White Sox. It doesn't happen often, but my brother and I have seen the trifecta a couple times.

That day was a lot of fun. And the kids got to get the whole experience with the Cracker Jacks and the hot dogs and the chocolate malt ice cream.

And they got to see the seventh-inning stretch even though they didn't know what was going on. They were dressed up in their Cubs attire. It was something special.

A lot of people haven't experienced Wrigley the right way or haven't experienced it at all. When I travel, I always tell people they have to come to Chicago. Even if you come for just a weekend, you have to catch a Cubs game. Win or lose, nothing beats it. Even if you're not a baseball fan, just take in the atmosphere—there's nothing like it.

FINDING A WAY ON THE FIELD WITHOUT GETTING BUSTED

MIKE TOOMEY, CHICAGO COMEDIAN/WGN-TV'S SKIP PARKER

Being on the field at Wrigley to do some of the Skip Parker sportscaster bits for WGN has been mind-blowing for me. The first time we did it was in 2005. We didn't know what to expect. Our first thought was that we wanted to do a funny one-on-one interview with Greg Maddux because he had just gotten his 3,000[th] strikeout. He was unavailable, so we just started looking around the field and talking to other players. It turned into a really fun package that we ended up getting. But it's weird because when you're down on that field, there's never a second when you're not going, "Oh my god. I'm actually standing on the field!" You never really feel like that's what you're supposed to be doing. It just feels like you're down there and nobody has found out yet, so you got to be ready to run because you're gonna get busted. The chance to be on the field never gets old. That excitement and awareness of what you're doing never goes away.

My parents were Cubs fans, and the Cubs games were always on in our house. I was never steered toward them; I just picked it up. The first time I went to a game was before I really became all that interested in baseball. I was a little kid, and they were playing the Phillies. The first one I really got into was also against Philly. I remember I couldn't believe what I was seeing in front of me. It was kind of like being on the set of your favorite TV show like, "Wow, here it is in reality." Going up the steps inside the park and seeing it all in front of me...until that moment, it's just a place on TV. It's not entirely real until you have that defining moment. Just as important, I remember bringing my kids there for the first time. Reliving that moment as a dad was a very cool thing, too.

As a kid, I remember our park district used to do trips to the Cubs games. We'd all get on the bus with chaperones and all of us kids. So, me and two buddies who had been to Wrigley enough just kind of ventured off to go do our own thing. We didn't want to be confined to the chaperones, so we took it upon ourselves to explore Wrigley and get autographs and hang out. When we got back to the group, they were so pissed off because we weren't supposed to leave them. We got in so much trouble. We couldn't go on any more park-district trips for the rest of the summer.

It's been cool for me to see it from so many angles—from the outside looking in, from the inside looking out, as a fan, a reporter, as a kid and a parent. It's spectacular from any angle.

A WRIGLEY CURTAIN CALL

REED JOHNSON, CUBS OUTFIELDER, 2008–09, 2011–12

I think the fans really make Wrigley. When I first got over there in 2008, in one of my first at-bats, I grounded out to second base. There was a runner on second or third base, and I had moved the guy over. As I'm running back to the dugout, the whole stadium was cheering. You don't usually hear that. The normal baseball fan is into the home run or the obvious play that kind of just stares at you. But I feel like the fans there really understand the game—they recognize the importance of advancing runners and those kinds of things, and I think that's really what makes that place special aside from it being one hundred years old.

One of my first games there was with the Blue Jays in 2005 in interleague play. It was really hot and humid. I think it was a night game, as well. I remember hitting a home run to left center and thinking, "Man, this place is just a porch." You play in April, May or June, when the wind is blowing dead in, and the place plays bigger than any other field you've ever played in. Then, throughout the summer, the place plays completely different. You've got to check the flags all the time. There's been games where I've taken batting practice in eighty-five degree weather only to come out for the game and it's fifty-five degrees and the wind is blowing in the complete opposite direction. I was in the American League East, so I played in old Yankee Stadium and Fenway Park and all these historical stadiums. Being able to go to Wrigley and get to experience baseball in another historical ballpark is really special for me.

One game that stands out was one we played against the Pirates in 2008. I had a pinch-hit two-run homer to take the lead in the eighth inning. It

was amazing to hear forty-two thousand people cheering for you to come back on the field. That was the first curtain call I ever got. To be able to come out on the field, tip your hat and listen to the whole stadium erupt… that was very special to me. That season in general, winning ninety-seven games, was special.

When I'm playing on a different team, I always look at the schedule to see when we're going to Chicago. There's a big part of me that wants to go back to Chicago because it's definitely a special place, and I want to be there when that team wins. There will be nothing like it when they do.

WIND-BLOWN WILDNESS IN A 23–22 LOSS

STEVE SCHEE, LIFELONG CUBS FAN FROM CHICAGO

It was May 17, 1979, against the Phillies. My dad got tickets from his buddy, and I ditched school. I did a lot of that in my day to go to Cubs games. My dad and I, as well as about seventeen thousand others, had no idea what we were about to witness on a warm seventy-degree day with the wind blowing out at least twenty miles per hour.

You had a feeling it could be one of those days, especially with the high-powered pitching staff we had back then. Before we could settle in with our dry hot dogs and stale sodas—the food wasn't very good back then—it was already 7–0 Phillies behind Randy Lerch. Well, we figured it was just going to be one of those days until the Cubs came back with six in the bottom of the first behind a two-run triple by the late, great Donnie Moore. Back and forth we went. The Phils ran out to a 17–6 lead in the top of the fifth, but then the Cubs got seven in the bottom half of the inning thanks to a slam by Bill Buckner. Even the great Steve Ontiveros homered, thanks to the gale-force wind blowing out.

The best memory, of course, was the three homers by Dave Kingman, each one hit farther than the last. I swear the third homer hasn't landed yet. That thing hit the third house on Kenmore. It went six hundred feet if it went an inch. The Cubs tied it at 22 in the eighth on a Barry Foote single, and the place went nuts. For the actual 17,000 people there, it sounded more like 170,000.

Naturally, Mike Schmidt took Bruce Sutter downtown in the tenth to win it 23–22 for the Phillies. I didn't feel too bad about the game's

outcome, though, because I thought it was the greatest game ever. Even my dad, who went all the way back to the 1930s, said to his dying day that it was the best Cubs game he ever witnessed. And believe me, he watched a bunch.

THE BLACKHAWKS, MAE WEST AND TWO FOR DUTCH

TOM BOYLE, OWNER OF YESTERDAY ON ADDISON STREET

We've been here thirty-seven years. This building at 1143 West Addison is older than Wrigley Field. They're going to celebrate their 100th anniversary, but this building was first sold in 1884, so it's the right place for Yesterday. I'm not here every day myself, but when the Cubs are here, I'm here. It seems like a lot of people want to be in this area. But people who like a quiet area should not come here.

I'm glad we weren't around the night the Blackhawks won the Stanley Cup in 2013 and all the fans were down here. Most of them were well behaved, but some of them took baseball bats and bashed in windows and destroyed cars. We used to have a figure of Mae West out front where people would come and take pictures. Then, on the day of that big crowd, I told my associate to bring Mae West in. But she was gone, kidnapped. We've gotten no ransom notes, and she has not returned. She is in somebody's home or basement somewhere.

The Cubs have loyal fans. You have people who come from all over the country—even all over the world—just to be here. They plan their vacations around being here. Then you have people who have no idea what baseball is and just go to meet people to drink.

I've seen hundreds of games through the years. I've suffered through many years. One of my favorite games was a Sunday afternoon when Dutch Leonard, who was forty-two years old, won both ends of a double-header in relief. I was also out there when Hank Sauer hit three home runs in a game. Originally, for me, the field itself was the beauty of the park. I started

listening to games on the radio; we didn't have TV then. The guy I was listening to was Burt Wilson. He would always say, "The game isn't over until the last one is out." When I finally saw the field, it was just beautiful. I kept coming back.

I had never even thought about opening a store. I went to flea markets trying to sell things, and then I'd end up coming home with more stuff than I brought. I looked around different areas for a location. When we opened, it wasn't even baseball season, so I wasn't thinking about it at the time. Normally, our regular customers won't come in here on a game day because of the crowd. But when we first opened, there was a lot of gang activity, and the Cubs weren't even filling the ballpark. Now, imagine a little ballpark in the middle of a neighborhood drawing three million people.

45

WILL YOU MARRY ME?

TERYN FRANK, CHICAGO

Ken and I had been dating for nine years. It was our anniversary on April 3, 2011. It had always been a dream of mine to get engaged at Wrigley Field. I had told Ken that probably two years before that day. We went to Sluggers before the game, and he started to tell me how happy he was to be with me. I had anticipated a "congrats on your nine-year anniversary" message on the scoreboard. It got to be the seventh inning, and it hadn't happened yet. I left my seat to go to the restroom—I think he thought I was mad. When I came back to my seat, someone handed me a bag. I opened the bag, and there was a baseball inside of it that said, "Will you marry me?" He got down on one knee. I was so happy I was crying. He told everyone around us while I was in the restroom that he was going to propose. The photo we sent out with our wedding invitations was from a camera phone from the people sitting behind us. Everything worked out so perfectly. On our wedding day, I gave him a groom's cake with a red marquee sign that said, "Ken, I'm glad I didn't have to wait until next year."

PLAYING HOOKY

RICK MORRIS, FORMER CHICAGO-AREA RESIDENT

Wrigley Field—it's the original. I lived and worked here twenty-five years ago, so I'd been to the park a number of times. My daughter's thirteenth birthday was here with twelve of her little friends. We took a limo from Naperville, where we lived at the time, and went to Ed Debevic's for dinner afterward. It was a real special time.

A view west down Addison on Opening Day 2013. *Jenkins Imaging.*

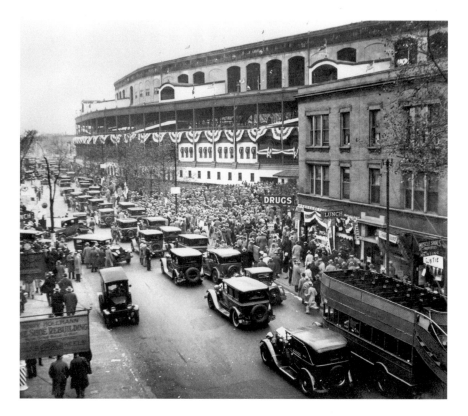

Fans line up to enter Wrigley in this elevated view of the park's southeast corner at Addison and Sheffield. While the park's shape remains the same, this area now is home to the Captain Morgan Club. *National Baseball Hall of Fame Library, Cooperstown, NY.*

In those days, 1987–89, I worked in the Standard Oil building on the north side of Grant Park. For day games, we'd run down to take the train to Wrigley, watch the game and then get back to work before anyone noticed we were gone. You'd have to wear a white shirt with short sleeves because you'd come to the park and sweat and you'd go back to work soaking wet. The people at work acted like they didn't know what we were doing, but they knew. They just didn't say anything.

THE GREATEST TELEVISION STUDIO IN THE WORLD

BOB VORWALD, WGN-TV DIRECTOR OF PRODUCTION

I grew up in southwestern Wisconsin in a farming community, a town of about three hundred people, but the Cubs were just a really big thing in our lives. My grandfather was a Cubs fan who had a tractor radio probably before he had indoor plumbing. One of the last things my dad did before he went off to Korea was take the train down to Wrigley Field to see one more Cubs game before he left.

My first Cubs game was on my birthday, June 23, 1969. I was seven years old, and I still remember it. It was amazing walking up those stairs and seeing how incredibly green and wonderful everything was. We got there early, and when the gates went up, we found some seats in the terrace behind home plate. The Cubs won 5–4 that day, and it was just the most exciting thing I'd ever seen in my life. That first day was magical. I got an autograph from Ron Santo and Ernie Banks, and it was just something I'll never ever forget. It was the most beautiful place I'd ever seen in my life. My parents told me that on the way home, I kept talking about how someday I wanted to live in Chicago and work for the Cubs. Years later, I've come pretty close with WGN and being a part of Cubs baseball.

When I got to Northwestern in 1980, I wanted to be in Chicago and near the Cubs. The first thing I did during New Students week was go down on the train to Wrigley Field and sit in the bleachers. And that wasn't the last time for the next four years. In August 1982, I was fortunate enough to land a job with WGN-TV as a sports assistant. I was actually paid to watch games and help out in the sports department. Jack Rosenberg, who was a legendary

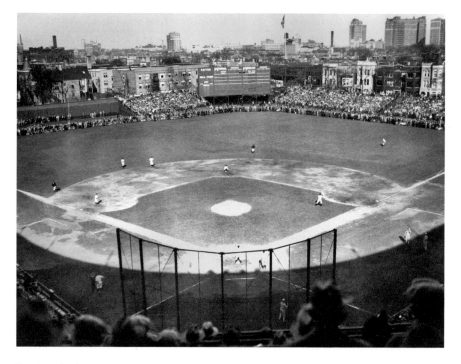

Rooftop shadows creep toward home plate as the afternoon sun shifts during this pre-bleachers-era game. The shadow, which now includes the park's light towers, often gives pitchers an advantage as they stand in the sun and the batters in the shade late in games. *National Baseball Hall of Fame Library, Cooperstown, NY.*

sports editor for WGN-TV, was the one who hired me. I did things with Jack Brickhouse and got to meet Harry Caray and do little things around the ballpark. I was hooked.

In 1998, I landed my dream job as director of production of WGN-TV, part of which includes running WGN sports and all our Cubs telecasts. It was an incredible time to be thrown into that. Kerry Wood had just struck out twenty batters in a game, we had the great Sosa-McGwire home run race and we had that incredibly flawed Cubs team that somehow found a way to get into the playoffs. That all culminated with another one of the most memorable things I've ever been a part of: the one-game playoff against the Giants. That was a wild night at Wrigley. The atmosphere was electric because there were only baseball fans there, no corporate types. That crowd was just nuts. Michael Jordan threw out the first pitch, and Steve Trachsel

of all people took a no-hitter into the seventh inning. I'll never forget Rod Beck coming in with absolutely nothing and getting Joe Carter to pop up. The celebration was on. It was a wonderfully fun night from both a work and a fan perspective.

Every day I get to the ballpark, it's a dream come true. Wrigley Field is unique. I call it the greatest television studio in the world. The fans are a part of the fabric of the telecast, probably as much, or more so, than any other stadium or city in the United States. One of the charms of Wrigley is that to get to the field, you walk right through the stands, and I think that's an incredible blessing for those of us who work here. It just reminds us every day how lucky we are to do what we do. We see the faces of those people and how important that particular game on that particular day is to them. It's great to be able to let people feel like they're a part of it. I'll attribute this line—and its perfect—to Bob Brenly, who calls it "single-day amnesia." This team could be 50–102, but if you get a good sunny day and the Cubs play hard and win, it's rocking in there. It never gets old. For that day, that game means everything. You don't see that at a lot of ballparks, and that's what makes Wrigley so special.

ANNABELLE'S FIRST GAME

RYAN JOHNS, HUSBAND/FATHER/LIFELONG CUBS FAN

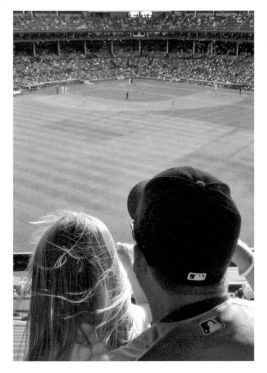

Ryan Johns and his daughter Annabelle in the bleachers for her first game in 2012. *Holly Johns photo (www.hollyjohnsphoto.com).*

Wrigley Field has this special power. It can transform the thirty-year-old husband and father into that twelve-year-old inner child everyone tries to · connect with. There is nowhere else like it. As soon as I walk through the turnstiles, I instantly begin to smile. It brings me . back to my youth. Some of my fondest memories are watching games with my dad, who, like me, is also a lifelong Cubs fan. In 2012, I finally got the chance to take my three-year-old daughter to her first game. As we walked up to the entrance, I glanced at Annabelle. She had this look of amazement on her face—like her young mind couldn't

comprehend what she was witnessing. I can imagine it was the same look I had the first time I went to a game. Everything about that game was different. I was the one explaining everything—from which team we cheer for to why we couldn't go onto the field and play, too. It truly felt as if I was passing on some great family treasure. Simply put, I guess this is the only time the child inside me will ever be able to meet my own child. And that is something very special.

A FIVE-HUNDRED-FOOT INTRODUCTION

RYAN DEMPSTER, CUBS PITCHER, 2004–12

It's actually kind of neat. My first-ever Major League start was at Wrigley Field for the Marlins. I remember punching out Brant Brown on three pitches and thinking, "This is going to be all right." Then I walked Mickey Morandini, and Sammy Sosa hit a five-hundred-foot home run. After that, I walked Mark Grace and then Henry Rodriguez hit a five-hundred-foot home run. I was like, "OK, maybe it's not that easy."

There are so many great memories of playing there. It's such a unique place. Even leaving games, I'd walk out behind home plate—and people never expected you to be doing that as a player. You just kind of blended in. For me, there were some fun experiences. I remember one night just walking with my mom and dad at like 10:30 p.m. and saying, "You guys want to go to Wrigley Field?" It was the only time my mom had been there. I took them on to the field at night at Wrigley.

We also used to check out the guts at Wrigley. I remember one time Koyie Hill and I went underneath with a flashlight and went back as far as we could find. We're pretty sure there's some bodies buried under there—it's just a bunch of dirt and nothing else. It was pretty neat, just like going up in the scoreboard. I waited a long time to do it, and I don't know why. It has one of the coolest views in the city. Other than that, I just tried to take it all in since I wasn't sure how long I was going to play there.

Now I'm playing for the Red Sox at the only park older than Wrigley. Fenway and Wrigley are both unique in their own ways, but both parks give you the feeling that you're walking into a baseball cathedral. When

you're walking into new Yankee Stadium, you're thinking, "Yeah, this new one is nice, but it's just not the same." Then you think about Wrigley and all the people who played there. The park still has the same feeling even with the changes they've made to the clubhouse and the bleachers to make it feel newer.

I really loved watching the ivy grow—it's one of my greatest memories. At home, you could see it start to come in and then you'd go on a ten-day road trip and come back and the whole wall looked like it'd been painted green. There's nowhere else like it; it's so special. During the season, balls get lost in the ivy and save you runs when there's a runner on first base. It's kind of like the goal post for a goalie.

I also enjoyed going to Wrigley as a visiting player. I always go out to centerfield to stretch. When you run out as a home player, they cheer you. When you come out as a visitor, you learn a lot of things about yourself that you didn't know. Living in the neighborhood also helped build up that relationship with the fans. You had an understanding of what was happening on a day-to-day basis and the atmosphere around there, whether it's the bars and restaurants or walking down the street to see the people out playing corn hole or tailgating on the stoops.

Spending eighty-one days at home for nine years, I really got to know the fans. They really had my back as a player, and it was the same for all of our players. From a team standpoint, I remember in 2008 we were down like 9–1 to the Rockies. It was June or July, and we took all our regulars out and put all the extra guys in. We ended up coming back and winning the game. I remember Henry Blanco hitting the go-ahead home run, and I swear the stands were moving from all the fans jumping up and down. Two of the greatest moments for me were the Winter Classic and the day the Blackhawks brought out the Cup. To have three major sports teams on the field at the same time taking a picture and then Ted Lilly takes a no-hitter into the ninth inning—what an incredible day that was.

ANYTHING IS POSSIBLE

DAVE HOEKSTRA, AWARD-WINNING WRITER/CUBS FAN SINCE 1966

My August 29, 1989 afternoon in the right-field bleachers is the hopeful pendant I wear around my neck. It is also a lucky tattoo on my pitching arm. That magical afternoon is the tonic for all the things that have since gone wrong. Work problems. Relationship issues. Lousy rock concerts.

Just when you think you're down and gone, life can change.

I witnessed it. I saw the Cubs come back from a 9–0 sixth-inning deficit. They beat the Houston Astros 10–9 in ten innings. Anything is possible when you live moment to moment, inning to inning. Just take a walk. I spent a half hour digging around my messy office looking for my scorecard from that game. Guess what? I found it.

I see there were 25,829 people who had their lives changed that day. I was with my friend Angelo Varias. We were already in year four as season ticket holders in Section 242, but we wanted to catch some late-summer rays. These were the days when there were more day games at Wrigley Field.

The Cubs were in first place in the National League Central with a 74–57 record. Mike Bielecki (14–5) started for the Cubs, Mark Portugal (3–1) for the Astros. Current Cubs announcer Jim Deshaies was an Astros pitcher, and Yogi Berra was an Astros coach. This game was certainly worthy of a Yogism, something like, "Don't take a chance too far."

The Cubs began their rally with two outs in the sixth inning. Portugal threw away a Shawon Dunston bouncer, and the Cubs jumped on the

chance, scoring their first run. Angelo had talked about leaving, but you never leave a game early. Anything is possible.

After Portugal's error, nineteen of the Cubs' next twenty-nine batters reached base—thirteen of them on hits. Even Cubs starting catcher Joe Girardi, hitting a paltry .196, received a ninth-inning intentional walk. The Astros built up their lead on a career day from shortstop Rafael Ramirez, who went three for five with a grand slam home run and seven RBIs.

But the Cubs chipped away. They were the suitor with blue orchids who did not take no for an answer. The Cubs scored 2 in the sixth to make it 9–2, three in the seventh to make it 9–5 and four in the eighth, when Angelo bought me a beer, to tie it at nine.

The Cubs kept on rolling when Dwight Smith hit his game-winning single off of future Cubs reliever Dave Smith. Dwight Smith had replaced starting right fielder Andre Dawson in the seventh inning.

Dave Smith walked three batters in one and one-third innings, giving credence to this modern-day Theo OBP thing. Center fielder Jerome Walton was zero for four with three runs scored.

Cubs manager Don Zimmer said it was the biggest win of his career. It was the Cubs biggest comeback win of the twentieth century, tying a nine-run comeback on September 29, 1930.

The Cubs won despite their storied post–Ron Santo problem of the inability to field a decent third baseman. Domingo Ramos, which sounds like the country off the peninsula of Portugal, started at third base for the Cubs. No matter, it was a good day. Frank Capra was in the house.

Amazingly, the Cubs lost to the San Francisco Giants in 1989 NLCS. I was also at the first game of the series where Greg Maddux got shelled 11–3 at Wrigley Field. No one saw that coming. Anything is possible.

THE LEGEND OF IVY MAN

WARD TANNHAUSER, CRYSTAL LAKE, ILLINOIS

On a Halloween camping trip in 1996, I came up with the idea for the costume. At that point, it was "Tree Man." It's made up of a green Starter jacket, green sweatpants, a wire mesh secured by an evergreen twine like you see at Christmastime and some attached leaves. It weighs about forty pounds. I also wear these shoes on plywood. Coming from a family of Cubs fans, someone suggested adding a "368" to the front of the costume to make me into "Ivy Man." What finally prompted me to take it to Wrigley was a trip to Field of Dreams in Iowa. I saw an ESPN crew there and asked them if they would film me around the park. They said it was something they might do if the Cubs made the playoffs. Basically, the voice said, "If you wear it, they will win." I wasn't really expecting what was about to happen.

I debuted Ivy Man at Wrigley during one of the final playoff games against Atlanta in 2003. I initially did it to raise money for the Juvenile Diabetes Research Foundation. Then, when my daughter needed a transplant, I did it for the Children's Organ Transplant Association. When I first wore it, the *Tribune* put a half-page photo of me in the paper. The response was amazing. For some of those playoff games against the Marlins, it felt like there were more people on Waveland than in the park. I'd raise my Ivy Man arms, and the masses would just start cheering. Of course, after the Cubs lost in Game 7 to the Marlins, it was very bittersweet. Everyone outside was so sad. They'd come up to me crying, like I was some sort of weeping wall. I was happy to do it given the circumstances.

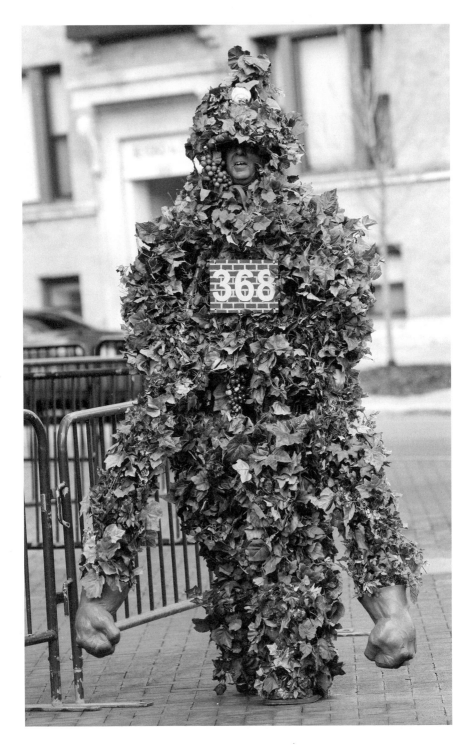

In 2005, the Hall of Fame called me about an exhibit called "Sacred Grounds." They had a photo of me as part of it, and they invited me to speak at its opening on Father's Day. I took my father, brothers and an uncle. Being able to address my dad, a longtime Cubs fan, on Father's Day at the Hall of Fame was wonderful. He passed away not long after that.

I'm technically never allowed into Wrigley, but I did get invited to the last Hall of Fame Game in 2008. I also was supposed to sing the seventh-inning stretch once with Fergie Jenkins, but the game was postponed by rain. Still, it's exciting to be part of the fabric of the park and neighborhood. I attend Opening Day and other big games like the playoffs, although that doesn't happen too often. It takes about fifteen minutes to put everything on, and then I'll take one or two walks around the park posing for pictures. I've done anywhere between two hundred to five hundred pictures, having leaves pulled off and, occasionally, getting groped in the process. I probably have to buy forty dollars in new leaves every year. The fans are great. One time, I fell down while walking. It was so touching because this crowd of people came over and helped me up. It reminded me of that scene in the Spider-Man movie where the people on the train help him get his mask.

From going to Wrigley for the first time as a seven-year-old with my grandfather to today, I'm just in awe of it all. To get a call from the Hall of Fame and everything else is so overwhelming. I just do it for fun now, plus I can make money winning costume contests around Halloween so that I don't have to work in October. What else do I have to prove?

Opposite: The Wrigleyville scene includes many unofficial mascots, including Ivy Man, who debuted during the 2003 playoffs. *Jenkins Imaging*.

52 AND 53

FATHER-AND-SON FANS FOR LIFE

WILLIE AND PATRICK YARBROUGH, ROCKFORD, ILLINOIS

WILLIE YARBROUGH

I started coming to Wrigley Field in 1936. Years ago, we used to park under the L tracks, and the price was $1.75 for a single game and $2.00 for a double-header. Now I'm shocked when I see parking is $50.00. The inflation has really surprised me. I advocate that baseball should be played in the daytime—like they do at Wrigley.

We usually come to two or three games a month. It's usually a good outing for me, although I almost froze in the upper grandstand against the

Mets (in May 2013) even wearing my heavy coat. The wind was blowing in off the lake. That was the most miserable game I've ever been to. Then I got angry because we blew the

Willie Yarbrough meets Cubs legend and longtime radio broadcaster Ron Santo on the ramps at Wrigley. *Patrick Yarbrough photo.*

game when that guy (Darwin Barney) tried to score at home and they threw him out.

A better memory is of the day I met Ron Santo right here at the ballpark and got his autograph. We discussed the good old days and how we should have won the World Series in 1969. I just knew we were going to the World Series. That was the most disappointing thing from that era.

Back in the day, Wrigley was always a friendly ballpark. It's still a family-friendly ballpark. Anyone who wants to take his family on a ballpark outing should come to Wrigley Field. Father Time has slowed me down, so my son brings me now. Thank God I've got a good son to bring me to the games now that I'm eighty-eight years old. I'm blessed to be here.

PATRICK YARBROUGH

When I was a little boy, my dad would bring me to Wrigley with my mom. We could walk up on the day of the game and buy tickets. We would usually get the lower grandstand behind home plate and sometimes up on the first-base side. Sometimes we'd sit in the box seats. When my mom would come to games, she would bring a book. She'd read a book, have a hot dog and drink a beer, and that would be a good day for her to come out to Wrigley.

I like the ability to come and see a game and interact with the players, and it's always had a good family atmosphere, unlike some other ballparks where people are rowdy and their language gets a bit salty.

The older Cubs—Billy Williams, Ernie Banks and Ron Santo—are my favorites. The reason for that is we had the opportunity to meet those players and get autographs and take pictures with them. They were very genuine. Even today, when you run into the players such as Ernie Banks, he's willing to stop and talk with you.

Our last encounter with the old Cubs was about four years ago. My dad—he's had a double knee replacement—was going up the ramp, and I looked down at the bottom of the ramp and here comes Ron Santo in his golf cart. Ron came up the ramp and saw my dad and he stopped and just started talking. I took photographs and asked Mr. Santo if he would sign our tickets. He signed them and took photographs with us.

One Saturday a while back, my dad and I came to town and decided to go to the game…and it was the Sandberg Game. It was tense, and a lot of people gave up. They thought perhaps the game was over and that the Cubs had no chance. It was one of my most wonderful days at Wrigley. A couple of years ago, I went through my stack of tickets and

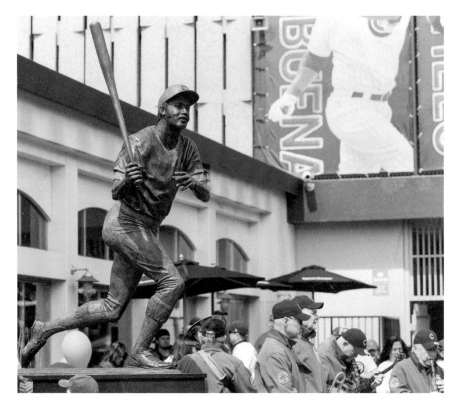

Billy Williams played sixteen seasons for the Cubs and was inducted into the Baseball Hall of Fame in 1987. *Jenkins Imaging.*

pulled out the one from that game. I was amazed at how inexpensive it was compared to today.

We bought one of the brick pavers here, and it has our family name on it. So when we come, we visit our brick. We have a personal stake here in the wins and losses of the team, as well as in Wrigley Field. Coming here always brings back good memories of being able to share times with my dad at a baseball game. It means a great deal to me—probably more than he realizes.

FOR BETTER OR WORSE

MICHELLE AND STEVE CUCCHIARO, CHICAGO

MICHELLE CUCCHIARO

Steve and I have been married for thirty-seven years. We moved into a neighborhood in walking distance to Wrigley. In 1976, Cubs tickets were extremely affordable. The partial plan in Section 26 was for weekends, which we both could attend, as well as holidays and Opening Day. Those seats were right behind the visitor's dugout. There were three other places they moved us after the *Tribune* bought the team.

It's not as much perseverance as it is determination. We continue to enjoy it, although maybe not as much as we did early on. It's a place to which we find ourselves going back year after year. I don't want to say it's because we think, "Oh, this is the year," because we truly don't think that—ever. Steve and I would just laugh every time we'd see someone with a sign that said "This is the year" because we knew it wasn't. We knew it wasn't even close to being the year. We found that very humorous.

A lot has changed. A lot of the people we got to know in our seats are no longer there. We have remained friends with some of them even though they have given up on the team. We have learned not to pay attention to the people who sit behind you and go on and on about every other thing going on in the world instead of enjoying what is in front of them—the thing they just paid $100, or not, to see.

For a while, and this isn't the way it is now, Wrigley was the place to be—like the Bulls in the '90s. People went because it was "see and be seen." It hasn't

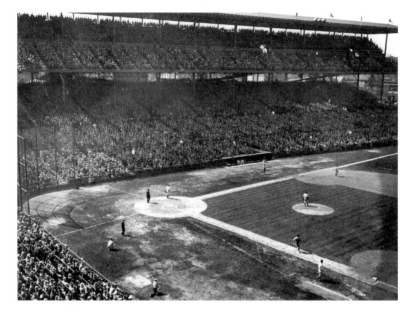

At first glance, much of the seating area bears a similar resemblance to today's configuration. Of course, a crowded Wrigley Field is also a welcome indicator of how well the team is playing on the field. *National Baseball Hall of Fame Library, Cooperstown, NY.*

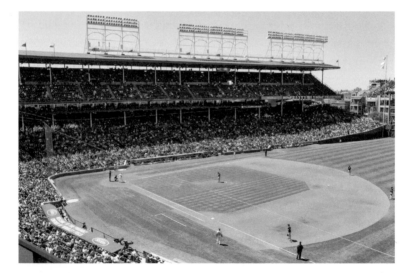

The addition of new seating behind home plate prior to the 2013 season means Wrigley now has one of the shortest distances in baseball from home plate to the back stop. The brick wall's angle also leads to funny bounces when a ball hits it. *Dan Campana photo.*

been that way at Wrigley for a while, but there was a time when that was the reason a lot of people went. Not me, not Steve, not our friends who sit around us.

The brawl with the Dodgers in 2000 happened right in front of us. Unfortunately, we weren't paying attention to the guy who came down there; we were trying to watch the game. It was surreal for sure—nothing like that we had ever seen. Every player who was on the bench started crawling over, pushing us out of the way. We were shoved into chairs. I had black and blue marks for days and probably weeks afterward. Steven and I couldn't find each other right away. It wasn't like we fell—we were being shoved aside. In all honesty, I don't remember it. I don't believe there's such a thing as blacking out during something like that, but I really don't remember it. I just remember seeing these huge, hulking men coming over the wall. There were fights in the stands because of these stupid, drunk fans hitting the Dodgers. You know, things have changed a lot with security over the years. We have people sitting on the field where we never had been before, and they come out between innings. At that point, there was nothing like that. People thought we'd never have a bullpen on the field again.

I've liked the concerts I've been to there. Maybe the sound system isn't perfect, but there is something kind of nice about the feel of being at a concert in a place you're familiar with for another reason.

There are days when going to the game doesn't feel like it's anything other than part of my life. I have to admit, some days I feel like it's a job. But once you walk in there, it's a whole different thing. It becomes an unparalleled place of worship. There's some days I sit there and think I'd rather be somewhere, but then I realize that I don't know where else it is I'd rather be.

STEVE CUCCHIARO

We had been big fans and had gone to quite a few games before we were married. Since we lived nearby, we just thought, "Great, let's do this." We did it. Those tickets in Section 26 in 1976 had a face value of $4.50. Plus, they would give us a discount of 50 cents a ticket, so it was like a dollar a game because we had partial season tickets. Now they don't give you any kind of break.

Even as a teenager and young adult, before being married, I always enjoyed going to the games because I would always meet someone who also enjoyed baseball—someone with whom you could spend two or three hours kibitzing about baseball, the game that day and the Cubs. It was very

enjoyable. It's still that way, but it's obviously a lot more fun when they have a good team. We know a lot of the people who sit by us—we've known them for many years, so we've built up relationships.

Things did start to change around 1984. Before '84, the people who came to the game, for the most part, were baseball fans. Once it came around, it seemed like the Cubs were the "in" thing. I mean, you started seeing women wearing high heels to the game. In '85 or '86, this guy comes in with his girlfriend, and he's talking about how he's the biggest Cubs fan around. Then his girlfriend excuses herself a couple minutes later. That night, Rick Sutcliffe happened to be pitching. This guy then proceeds to ask us, "Who is this guy pitching?" You know, Sutcliffe was only the biggest thing at the time after what he did in 1984 going 16–1. I said to myself, "Yeah, you're the biggest Cubs fan and you don't know who Rick Sutcliffe is." I mean, he was bigger than life out there.

I remember the fight with the Dodgers. I was watching the play and caught something in my peripheral vision. I thought, "Wait, is that a player?" It was Chad Kreuter going up Aisle 36. I had no idea why he went into the stands. It just escalated from there. The players were yelling at the people behind us. I remember seeing the faces of some of the players—Eric Karros, John Shelby, Rick Dempsey and Gary Sheffield. Some of them looked angry, but some of them were there just to support Chad Kreuter—maybe they thought he was attacked. Later on, we found out it was because some guy had taken his hat.

The September 2003 double-header against Pittsburgh was a great day. The Cubs beat the Pirates in the first game. We knew that if they won the second game, they'd win the division. It was a long day, but to me it was one of the most exciting days because we were near the field when the players were celebrating. Of course, there's Game 6 against the Marlins in 2003. It seemed like people were really having a good time up until the top of the eighth inning. Unfortunately, the park turned pretty nasty pretty quick in that inning. Moises Alou was too demonstrative. If he had just gone back to his position without showing his displeasure of not having caught the ball, I don't know that the outcome would have been any different, but I think the mood of the crowd would have been different. That's when everything seemed to turn. And Alex Gonzalez should have gotten at least one out. If he gets one out there, it's a totally different game.

Even with everything that's gone on all these years, if the Cubs ever get a chance to play in the World Series at Wrigley, I'd think there'd be mostly baseball fans in the park. I would love to be there, too.

A BIG KID IN A CANDY STORE

JAMES JORDAN, VENDOR AT CLARK AND WAVELAND

I'm a licensed vendor selling peanuts and t-shirts. I sell for the Cubs and the Sox, but I like the Cubs better even though I grew up on the South Side. The people are friendlier and more easygoing at Wrigley. I'm pretty much here at Clark and Waveland all the time, usually until the third inning of games. I feel like I'm a part of history and tradition—peanuts, Crackerjacks, hot dogs and beer. Being able to stand right here and look at the ballpark, it's like, "For real, really?"

I've met all sorts of people working out here. Jackie Bange from WGN, she was a regular person. I met Ron Santo, and he signed my cap for me. Scottie Pippen walked through here. Kirk Hinrich walked by with his buddies once. Usually I give fans instructions on which bars to go to. I say Bernie's or Rockit are good places to relax—Bernie's for the older group, Rockit for the younger crowd.

During my first year as a vendor, fourteen years ago, I went to my first game and was like a big kid in a candy store. It was like the movie *Field of Dreams*—you walk up the stairs in the ballpark, see the field and go, "Ahhhh." I get to about five games a season. I have loyal fans that come by to talk with me, ask me if I'm going to the game and give me a ticket. Bam, I'm in there. When you're going to the ballpark, it's something you can't explain. Everyone has a different thought, a different feeling when they get there. It's a great place to call work and home, too. I know the neighborhood real well; all I'm missing is an apartment here.

WIN ONE FOR DAD

KIMBER FITZ-RICHARD, ROSCOE, ILLINOIS

As a little girl, I can remember baseball always being a part of my life. My dad was a big baseball card collector. I remember him getting excited at an auction when these old library card catalog filing systems were up for auction. He looked at me and said, "These would be perfect for storing my baseball cards." That was the least amount of time we ever spent at an auction. He couldn't wait to get home and start organizing his collection.

My dad was the biggest St. Louis Cardinals fan I've ever known. Growing up in a home with a Cardinals fan, you would think I also would be a fan of the team. I'm a Cardinals fan at heart. Since losing my dad in August 2003 to lung cancer, it's one of the only things I still share with him. So in September 2010, when I had the opportunity to go to my first Chicago Cubs game, I couldn't be more excited that they would be playing the St. Louis Cardinals that day. The St. Louis Cardinals—my dad's favorite team!

I remember sitting in complete awe of the field, the players and all of the fans surrounding me and thinking about how my dad never got to experience the sight of seeing his favorite team play other than on TV. I took it all in hoping that he was experiencing it with me from above.

Now, I would never want the Cubs to lose, but this time I didn't mind. It was a close game, but the Cardinals did win 8–7 that day. Even though it was bittersweet, it will always be the best game I have ever seen.

AT HOME FOR THE SEVENTH-INNING STRETCH

DENNIS GUTIERREZ, LIVES HALF A BLOCK FROM WRIGLEY ON KENMORE AVENUE

There's no better place than Wrigleyville. I moved around the city and suburbs a little bit but have lived here for a few months on Kenmore, about six or seven houses from Waveland, right down the street from the park. It's a nice neighborhood—you could raise children here. It's also like a party atmosphere. It could be a Tuesday and you're like, "Hey, I want to have a good time." So you just go right out into the neighborhood and enjoy yourself for two hours and still get home in time to sleep and make it to work the next day.

Sometimes when I'm going to the 7-Eleven to get something, I'll stop by that spot on Sheffield where you can see right into the stadium to watch a few pitches and then keep on walking. There are always people just standing there. Where else can you really do that?

I've been a Cubs fan since I can remember. I have an older brother who wanted to go to Wrigley for his tenth birthday. My parents took him, but I didn't go. Later, they ended up taking me, and I just fell in love with Wrigley Field. That same year, I did a Cubs Care event where I ran on the field and touched the ivy. I was like, "Holy crap, I'm touching the ivy!"

People always ask how awesome it is to live here or if the parking sucks. The parking is not a big deal if the Cubs aren't playing or if you get here before the game starts. I love living down here. During the seventh-inning stretch, we open our windows, and you just can hear everything. I love living this close to the park. No matter what's going on and even if you don't follow the cubs, you know whether they win or lose because you're right here.

59

OPENING DAY IS A HOLIDAY

TRISH BERRY, ADOPTED CUBS AS HER TEAM WHILE ON WEST COAST

I've been a Cubs fan since I moved here in 1986, but I really adopted them while living on the West Coast because we didn't have a baseball team. WGN was a big part of that. Our fan group sits in the same area of right field every time—four rows up, right on the aisle. They started

Wrigley Field's iconic marquee welcomes fans to Opening Day 2013 at the park's main entrance. *Jenkins Imaging.*

sitting in right when Andre Dawson came to the Cubs. I love sitting in the bleachers with them because of the tradition. Our friends keep score, we taunt the other team nicely and, on a nice day, you're guaranteed to be in the sun all day.

We went to an Opening Day game about ten years ago and didn't realize it was going to be as warm as it turned out to be. No one had any sunscreen, and we got so sunburned that we blistered. Still, Opening Day is like a holiday in our house. And there are other moments, too. Kerry Wood and Mark Prior in 2003 were pretty memorable for me. I was here when Sammy hit number sixty-one. For me, it's the nostalgia and history of this building. I also fell in love with my husband out there. To keep all that going, we've been coming out to buy tickets on the first day for ten to fifteen years. It really gets us geared up for the season.

60

WRIGLEY FIELD AS ART

PAUL ASHACK, ARTIST/VENDOR

After forty-two years as an illustrator for the *Chicago Tribune*, the paper ran into a little bit of trouble. Fortunately enough, they gave me a good buyout because of my tenure. Before I left, people at the *Tribune* would say, "You oughta do Wrigley Field." So I did one called *Game Day* and had reproductions made, and everybody in the office was buying them. I said to myself, "Odds are, if I took these to Wrigley, people would like them."

At sixty-two, I started selling my paintings. It was right before Dusty Baker almost took them to the pennant about ten years ago. In 2003, there was such an excitement in the air. Every time I got close to the park, my blood pressure and heart rate would go up. It was an exciting time for the team and an exciting time for me because I'd get all these compliments and people would buy the prints. When I first went out there, I didn't have a vendor's permit. There was one policeman who used to check me and chase me away. He said, "Why don't you go get a vendor's permit?" I didn't know anything about how to get one. You had to go to city hall, but finally I got a vendor's permit. That police officer and I became real good friends.

Wrigley is such a unique place, more so than any other ballpark in the country. It's a good time, win or lose. People like to keep that memory, so they get a little souvenir. *Game Day* captures the circus atmosphere of the big crowd walking around Addison and Clark. I like to put a lot of people in paintings because that gives it life and excitement. When people see that, they feel like they're part of the crowd, they're bringing it home with them. There are a lot of people who don't like crowds, but when you're at Wrigley,

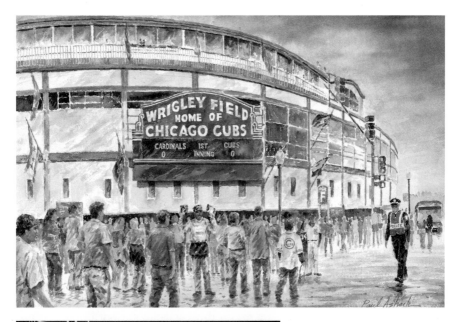

Above: *Game Day*, by Paul Ashack. *PaulAshackStudios.com*.

Left: Paul Ashack shows off his painting *Game Day*, of which he sells prints outside of Wrigley. Ashack has sold thousands of his prints to fans looking to remember their day at the park. *David Levenson photo*.

it's an atmosphere of excitement; it's not like people bother you. You're all hoping for the same thing: a win and a good time. And the crowd...it's so stimulating when you hear the crowd roar for a home run.

There is one moment that stands out in my mind. I was walking down Clark Street right by the Cubby Bear. A nice-looking young man came out with this pretty blonde and said, "Oh, I want that print. I don't care what it costs—I gotta have that." He bought the print and then said, "I'm from Southern Illinois, and I've never had a better time in my life." He looked like he had tears in his eyes. "This is the best fuckin' time I ever had," he said. I don't know if he'll ever be the same going back to Southern Illinois after spending time at Wrigley.

The day games are what I enjoy. If it's a 1:20 game or a 3:00 game, I'll be down there about 11:00. I'll meander around, talk to people and visit with some friends. A lot of people don't like to carry prints into the game, so they'll buy the smaller print or get my card and come see me after the game. Usually I watch games at the firehouse sitting on the couch. I enjoy their company. If I got a ticket, I gotta go in. But I have to get out in the seventh inning anyway because that's when people start filtering out. That's when I make my sales, so I gotta be ready. I feel as though it's one happy family, especially with the vendors and the rooftop people. I love the place—I call it spring break for adults.

61

WRIGLEY "RUINED" BY WINTER CLASSIC (IN A GOOD WAY)

ERIC BRECHTEL, BLACKHAWKS/WHITE SOX FAN

Even though I'm a White Sox fan, I'd never been to Wrigley for anything other than baseball. Seeing it transformed for the 2009 Winter Classic was one of the coolest things ever. I will never forget the feeling I had as we entered the stadium and saw the rink for the first time. I was speechless.

As a sports fan, I have never seen a better venue for an event. Honestly, the Winter Classic has basically ruined Wrigley for me. It will never look as great as it did that day. The ballpark wasn't the only thing that had changed; the neighborhood had completely transformed as well. All the street vendors were selling Hawks memorabilia, and the huge signs outside of Wrigley had Hawks and Red Wings players on them.

Of course, there was the national anthem—such an amazing experience. You had more than forty thousand people cheering as loud as they could. It was so loud that I couldn't hear the jets doing the flyby. I knew they were loud because you could feel it when they flew over.

Was I upset the Hawks lost? Of course. I was actually pretty mad at the time. But I took as many pictures as possible and realized I had been part of something so awesome that, at the end of the day, the outcome didn't really matter.

ME AND WILLIE MCGEE

MATT JUNKER, CHILLICOTHE, ILLINOIS

I grew up in Central Illinois, where the Cubs-Cardinals rivalry is especially strong. The rivalry for me was and still is split along family lines. Everyone on my mother's side of the family is a Cardinals fan, while my father's side roots for the Cubs. The tug of war for rival baseball allegiances is at the heart of my initial experience at Wrigley Field.

My first trip to Wrigley was in April 1984 for a game between the Cubs and Cardinals. The weather conditions were typical for an early-season game in Chicago: cold, damp and overcast. I was six years old and absent from the Varna Grade School kindergarten that day, accompanied by Grandpa Gene Smith, my Aunt Brenda and Uncle Larry Stewart—all Cardinal fans.

At this early point in my life, I enjoyed watching both teams. Ozzie Smith and Ryne Sandberg soon became my favorite ballplayers, but I had not yet chosen an allegiance to either side.

We arrived early at Wrigley Field, bundled in winter coats and stocking hats, and found our seats in an area between home plate and the visitors' dugout. My Cardinal-fan family members noticed a few St. Louis players interacting with fans near the dugout and coaxed me into walking down the aisle to field level to get a few autographs on my program. I slowly walked down toward the field and soon recognized one of the players signing autographs was No. 51 for the Cardinals, Willie McGee.

As McGee signed items for other fans, I waited back in the aisle and then moved toward the field when it was my turn. However, when I moved down the aisle to field level, Willie turned away and walked into the Cardinals

dugout. I walked back to my seat a dejected, confused six-year-old without an autograph—and possibly with a better idea of which team I should root for that day.

So did I become a Cubs fan because Willie McGee blew off an autograph request? Not entirely, but the incident might have played a part. My Cub fandom grew with watching "The Sandberg Game" on TV a few months later, as well as the numerous games my brother, sister and I saw on Superstation WGN every summer. As one can imagine, family get-togethers on my mother's side always produce lively baseball discussion pertaining to the Cubs-Cardinals rivalry.

NOT AN ORDINARY INTERNSHIP

CHRISTINE COLEMAN, FORMER CUBS INTERN

During my summers off from college in the 1980s, I worked at a Quad Cities factory that made trophies and ribbons. It was a really boring job. I'd spend all afternoon listening to Cubs games on the radio whenever they were playing at Wrigley. One day, Harry Caray interviewed the media relations director, Ned Colletti, who is now general manager for the Dodgers. He talked about the people who worked in the department, including the interns. I thought that would be really interesting to do. I had a journalism degree, and I'd always been interested in sports. There was no Internet back then, so I wrote a letter to Ned Colletti seeking more information.

In my senior year, I got called in for an interview. That was just amazing—just walking in through the front office door at Wrigley was the coolest thing in the world. In the interview, they asked me what I knew about baseball and the Cubs. I had to take a test with pencil and paper to prove my knowledge of baseball and stats—pre-Internet days. I got the job and worked January through June 1988. They even asked me to come back to work the first night game in August 1988.

It was always really exciting to walk in every day. I lived in a tiny apartment on Clark that I rented four or five blocks away from the ballpark. It was exciting to walk up and go in. It was like, "Wow, here I am!" After a while, it was kind of just a job. I went into it thinking it was going to be this grand and glorious thing, and while parts of it were, there were other parts where it was just a job.

I worked the night when the Chicago City Council passed the ordinance allowing night games at Wrigley. It was really cool. We were waiting to see

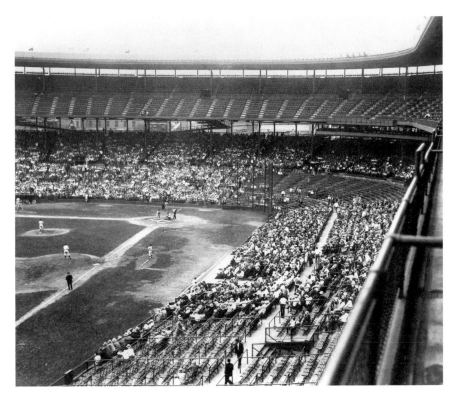

Wrigley's double-decker seating configuration puts fans right on top of the action. It is divided into the closer box sections, known as the 400s, and the reserved sections, designated as the 500s. During some lean attendance years, the entire upper deck would be closed to fans. *National Baseball Hall of Fame Library, Cooperstown, NY.*

what was going to happen, and we had a news release ready to go, assuming the council was going to pass it. We divided up whom we were going to call and whom we'd fax it to. I remember hearing my voice on WLS Radio—I was identified as a Cubs spokesperson. The construction of the lights occurred while I was still there.

It was cool when the games started; they'd ask me to research things. It was so different then because you had to look through books and game logs and old media guides. That part was cool because you never knew what was gonna happen.

On August 8, 1988, the first scheduled night game, I was busy running around and don't think I saw the lights turned on. We all had different responsibilities, and there was tons of extra press to deal with. At some point in the fifth or so inning, non-local TV stations were going to be able to go

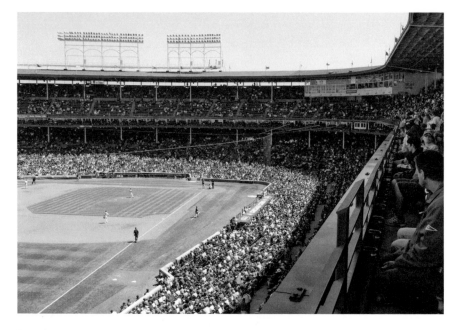

In 1989, a new press box debuted in the upper deck directly behind home plate to replace the old press area that hung beneath the upper deck. Private suites now line the upper deck's underside. *Dan Campana photo*.

out to the right-field bleachers and shoot their own footage. That was my responsibility that night, but it never got to the point for that to happen. So I was just out in the right-field corner waiting for this appointed time to come that never did, and then the rain came, and it was kind of crazy.

The amount of press the next night was tremendously different. The game was on NBC that night, and I got to be with their TV crew in case they needed a runner for anything. I had the best seat I ever had for a game at Wrigley Field. I was in the front row of the upper deck, right behind home plate. It was an amazing view. I've always wanted to sit there again but never have.

It's a wonderful ballpark. Most of my family are Cubs fans and have gone there since I was a kid. The first game we went to was in the '70s, a Cubs-Reds game, because my brother was a huge Johnny Bench fan. It's different going now because I look at the press box and it's not the same place I worked. But I do still enjoy going there. It's such a historical stadium.

CUB FAN, POLICEMAN

JIM MCGOVERN, SEASON TICKET HOLDER/FORMER BELMONT DISTRICT POLICE OFFICER

I've been involved in a season-ticket group for about fifteen years, but I've been a Cubs fan my entire life and going to games at Wrigley since I can remember. We'd occasionally go with my father, but a lot of the time it was with my older brother. He would take me and my other brother, who is two years older, on the bus and train to get there. This would have been the late 1950 and early '60s.

The park was pretty much what it is today, except that the grandstand had open seating. They weren't assigned like they are today. My father used to like to sit in the grandstand. My eldest brother liked to sit in the bleachers. Then, when my other brother and I would go, we'd sit in the grandstand. We enjoyed when the Smokey Link cart would show up in the latter part of the game.

In the bleachers one day, my brothers and I were in the second row, and Ed Bouchee, first baseman for the Cubs, hit a home run that was coming our way. All I can remember is that it went off my hands because I was small and deflected to my older brother, who was probably sixteen at the time. As the ball was going toward him, I realized the rows behind us—three and four—were all falling forward reaching for the ball. Three of us got buried in a mass of humanity. I was on the edge of it and remember crawling out. We probably missed three or four batters. I finally saw my brother on the bottom of the pile with the ball clenched in his hands. He held onto it. We got the ball and swore we'd never play with that ball, but by the end of the summer, it was all used it up.

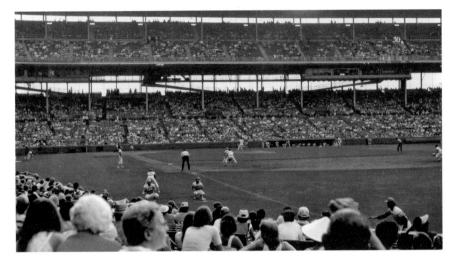

A pre-lights view of the field from the right-field grandstands. The location of the old press box below the upper deck and position of the dugouts are two other obvious changes from Wrigley's more recent configuration. *National Baseball Hall of Fame Library, Cooperstown, NY.*

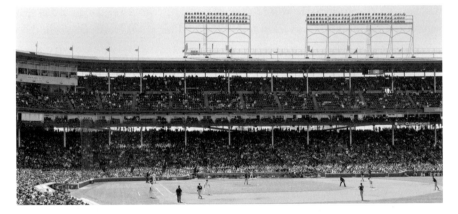

Wrigley's roof is lined with flags commemorating significant players or achievements in team history. The two foul poles bear the retired numbers of Ernie Banks, Ferguson Jenkins, Greg Maddux, Ryne Sandberg, Ron Santo and Billy Williams. *Dan Campana photo.*

We were in the bleachers for Don Cardwell's no-hitter in 1960. A lot of people were jumping on the field after the final out—this was before the basket days, but it was too big of a drop for us. All we did was grab as much ivy as we could stuff in our pockets. That was supposed to be our souvenir. It turned into brown leaves about two weeks later, and my mother threw it all out.

As a police officer, I worked the Belmont District, which encompassed the Wrigley Field area, beginning in 2005. Every Cubs night game was going to be an interesting night for us at work because of all the bars. The park was full, and so were the bars. Every game, we had several Cubs fans in the lockup for minor offenses: drinking, fighting or pissing in the gangways. Sometimes we'd have a crazy fan that would run onto the field. Before I retired a few years ago, I used to kid my people that I was going to end up in my own lockup for running on the field and sliding into second. I haven't done that yet.

I mostly worked the West Side of Chicago during my career and had never been assigned a district north of Division Street before going to Belmont. I knew it would be quieter, but of course you've got different problems. It's a different job really. Working the midnight hours was somewhat of a challenge because we were working the busier times of the day. I didn't mind cleaning up messes and putting out fires; I sort of enjoyed it. A big change for me was not dealing with the violent crime. A lot of guys like to be assigned there because of the Wrigleyville neighborhood or because it was considered a safer area. As far as the work, we did not see too much violent crime. Of course, you had to have patience to deal with drunken people a lot of the time. It's hard to reason with a drunk.

Prior to becoming a captain and watch commander near Wrigley, my team would occasionally get assigned to special patrols at Cubs games. My team and I were assigned for the first night game, which turned out to be a bust. We got down there early with all this preparation and pep talk. We hung out trying to dodge the rain for four or five hours—the game turned into a rain out. The next day, they played the first official night game, but we were off.

65

CATCHING "THE BOSS" IN THE BACKYARD

DAVID STONE, LIVES ON WAVELAND AVENUE

My girlfriend and I have been here about a year. For us, the apartment was perfect. For me, it wasn't so much about the neighborhood as it was the actual unit. My girlfriend wanted to live in Wrigleyville and around all the action. The walkability and energy of the neighborhood is great. You can walk to the Red Line and all the restaurants and bars. Parking, traffic and drunken people are the worst parts. The Cubs suck this year, so it's been quiet. Living here is great for concerts. You can sit in the backyard and hear it perfectly. In 2012, we sat in the backyard and listened to "The Boss," Bruce Springsteen, and it was awesome. We have a parking spot that my girlfriend uses, but I park on the street. I don't have a normal nine-to-five job. I usually work from home or on the road, so the parking isn't terrible for me. If I can't find a spot, I'll just pull in the back and wait for people to leave and then head out and grab a spot.

BLEACHERS ARE NICE, BUT I'LL STAY IN THE INFIELD

LARRY BOWA, CUBS SHORTSTOP, 1982–85/MLB NETWORK ANALYST

O ne of my greatest times was playing in Chicago—I loved it. When I went there, there were no lights. The biggest complaint a lot of guys had was that if you played your whole career there, the day games would wear you out. I didn't play there that long, so I thought it was something special. You get up in the morning like a regular job, come home, have dinner with your family and get up the next day and do it all over again.

Of course, 1984 was a tremendous season for us, even if we came up a little short of our goal. Before Dallas Green, they didn't draw too many people. Then, all of a sudden, it was packed. It was a great environment to play in. It was night and day. In the years before '84, you probably could have sat anywhere you wanted to sit. It used to be a fun place to play when you were the opposition because you didn't have to worry about fans.

In '84, it was a crowd that got into it right from the start, not one of these late-arriving crowds. These people were avid fans, and then you had the bleacher people out there in the outfield. Those people have more fun than anybody. I remember Tug McGraw with the Phillies would take a hose out there and spray them when it was a real hot day. They'd love it. Of course, they'd shout some obscenities here and there.

When you play shortstop, you don't hear those things. Greg Luzinski was a left fielder for us and a Chicago native. We happened to be on the bus one day, and I said I liked playing at Wrigley, and he goes, "Why don't you come out and play left field. I want you to come out there during BP one day." So, I went out after taking my ground balls, and it was unbelievable some of the

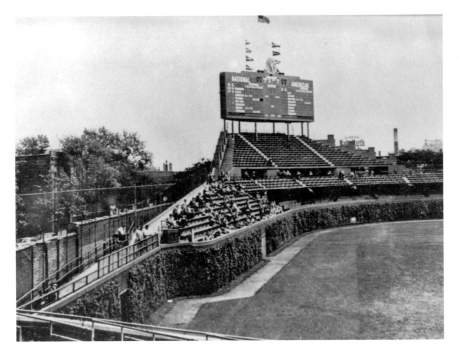

Wrigley Field's bleachers have gone through several changes in the last thirty years. This undated photo depicts the old catwalk in left field, as well as seats in dead center, where a hitter's backdrop now exists. *National Baseball Hall of Fame Library, Cooperstown, NY.*

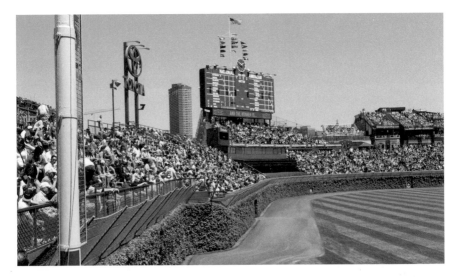

Among the changes to the bleachers in recent years include the installation of the Toyota sign in left and the addition of an enclosed private seating area in centerfield that blends in as a hitter's backdrop. *Dan Campana photo.*

language. They were having fun. I said, "I'm glad I play where I play, Greg. You can handle this out here."

My first year was in 1970. The ivy and the brick stood out in my mind. You go in there in April, and it's all brick, but then you come back in June or July, and you see the ivy. When I first came up, the clubhouses were a lot bigger. It reminded me of old-time baseball, not the cookie-cutter parks and all the Astroturf fields. The wind was something everyone talked about before your first game. They'd say, "Wait until you get to Wrigley—one inning it's blowing in, the next minute it's blowing out."

I took batting practice there as a member of the Cubs. You go out there in short sleeves, and the ball is just flying out. We'd go in, because we hit first, and come out with guys in turtlenecks and the wind is blowing in. I saw that happen a lot. The favorite line there is, "You think the weather's good now—wait a minute, it'll change." I literally saw weather change in the middle of a ball game.

AND THEN THE GAME STARTED

JOHN HANSON, ROMEOVILLE, ILLINOIS

The anticipation and excitement would peak on the night before we would go to Wrigley Field for a game and continue all the way through the moment the Cubs took the field. Each game was an event, almost a vacation for us. We lived close enough to the city to go a few times a year but far enough away to where it took plenty of coordination and advanced planning to make going to a single game a pretty special event in our eyes.

The night before a trip to Wrigley, my mind raced of that beautiful ballpark and my Chicago Cubs. I'd get my bag, my binoculars, a pen, the baseball with the autographs I'd already gotten and my Cubs hat with the pins and buttons. The baseball was almost full. I wished I could just get Ryne Sandberg to sign it. I couldn't believe Harry Caray took up a whole side of the ball with what he wrote: "Holy Cow Harry Caray." The preparation would always involve which baseball cards to bring each time. I'd bring at least one of every player on the team. Inevitably, I'd wake up in a panic after dozing off mid-preparation with the lights on. It would be time to go, but I'd quickly check those cards one more time and make sure I had a good pen so Dad wouldn't want to touch up any of the autographs again.

Soon, I'd climb into the truck for the first ride of the day. It would be about a half-hour ride from our house in Spring Valley to Grandma and Grandpa's house near Mendota. Next, I'd climb into the back of Uncle Paul's van for the ride that would finally get us to Wrigley Field. The next stretch would be a long ride, so I'd have plenty of time to study and sort my cards. I would quiz myself on the whole team. Davis? 7. Durham? 10.

Moreland? 6. Sandberg? 23. Sutcliffe? 40. It was so easy, and I still use those players' jersey numbers to help me remember things like PINs or garage door keypad codes.

It would be time to go up, and I'd get lost in the sensory overload of Wrigley Field. I could smell hot dogs and popcorn. I could feel the breeze as we ascended. I could start to see the sky and hear more and more as we got closer. I could see the scoreboard. I could see the bleachers and the ivy on the outfield walls. Wow—I could see everything when we got to the top! The whole team would be out there. The field would look so perfect. The fans would be coming in. I could hear the cheering from the bleachers for each home run. I could barely spend enough time trying to figure out who was batting before there was something else to look at. I'd wish we could live there as I spotted some people on the rooftops. Lee Smith was out there shagging fly balls, and Harry Caray was behind the batting cage. I was convinced that batting practice was the best part!

We'd find our seats, but I'd have more to accomplish in my quest for autographs. I loved leaning against the brick wall down by the dugout during batting practice. While I stood there, I thought how seats that close must cost a lot of money and how people are so lucky to sit there for a game. Back in my seat, it would be time for the binoculars. I'd scan the field as the grounds crew would prep for the game. The ivy looked soft, but I'd imagine it would hurt if anyone ran into the wall because of the bricks behind it. I'd be puzzled over the many people who'd take their shirts off in the bleachers. It was always chilly where we sat. I'd hope to sit out there sometime and maybe get a home run ball.

I'd see workers inside the scoreboard and dream of having that job. The binoculars allowed me to see Harry Caray and Steve Stone so clearly in their broadcast booth. Sooner or later, I'd spot the players getting ready in the dugouts and know that it was almost time to start. I can recall one occasion where I watched the cute ball girl through the binoculars while I followed her bringing baseballs to the umpire. I remember getting busted by my dad because I must have followed her path for quite some time. The National Anthem meant that they were about to run out onto the field. I'd be practically falling off of my seat with anticipation since I thought that absolutely had to be the best part. I'd need to stand on the seat to see as my mind raced with the rapid-fire recognition of each player as they ran out to the cheer that filled Wrigley Field. Of course, Dad was watching our Cubs take the field too, but I can still remember seeing him smiling at me in one of those moments. I don't know what I looked like as I watched them take

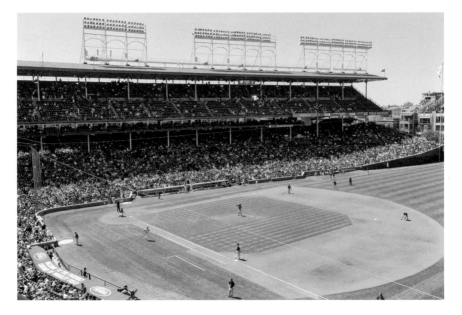

Longtime fans understand that where you sit determines how you dress for a game. Seats along the third-base line lose sun as the day goes on, while most seats on the first-base side get unabated sunshine all day. Depending on the time of year, choose your attire wisely. And don't forget, Wrigley temperatures are often affected by the lake. *Dan Campana photo.*

the field, but I know every inch of me was tingling with excitement and pride for my team…and then the game started.

A MEMORABLE FIRST IMPRESSION

MITCH WILLIAMS, CUBS PITCHER, 1989-90

My first day in the National League for Opening Day 1989 with the Cubs—that's probably one of my more memorable moments in my baseball career. Sutcliffe had pitched really well. I came in in the eighth, got out of the eighth and made it to the ninth. After I gave up three broken-bat singles in a row, I was thinking, "The National League ain't all that much fun." Mike Schmidt was coming up. I had just watched a special on WGN before the game about Mike Schmidt and the fact that he had fifty-one career homers in Wrigley. And that actually went through my mind when he came up. I knew nothing about him or about how to attack him because I had never faced him. So, I just went at him and struck him out. I knew the next two guys—Chris James and Mark Ryal—because I had faced them in the minor leagues, so I felt a little better about them, and I struck them out, too.

When you're doing that job as closer for the first time, you're not only looking to get your teammates' confidence, but you want the crowd behind you as well. Even if I tried, I don't think I could have scripted a better way to start my career in the National League—especially in front of the Wrigley fans. It was a lot of fun that season. You look back at the guys that were brought up. Dwight Smith and Lloyd McClendon both came up and hit well. Every button Zim pushed that summer worked. I had a very good year, but at one point, Les Lancaster came up and threw thirty-something scoreless innings. Everything was working.

I remember from May 27 on, they sold 6,500 standing-room-only tickets. It was packed. It didn't matter where you went if you were a Cub. I had

valet guys come out and take my car in traffic if I was going out. The fans always treated me well, and it didn't matter if I was with the Phillies or with Houston. What makes the field so cool is that you're so close to the fans. In the bullpen, you're sitting there and they can actually slap you in the head if they want to. That's what set Wrigley apart from every other place. They would just root us on all the time.

I probably remember the bleacher people a lot more because you saw the same people every day. And you always watch the ivy as a player. In April, it's just brown, but then you watch as it grows throughout the season. To me, it's just a really cool place to play. In my opinion, there are only two ballparks that haven't changed due to peer pressure: Fenway and Wrigley. They're like two little-league parks they poured water on and grew into big-league parks. I love the fact that they haven't given in and changed. As long as they leave it in Wrigleyville and don't change the basic outline of it, I think it'll be fine.

A BIG BALL OF WONDERFUL

TINA ROSSINI, ENGAGED AT WRIGLEY IN 2011

My love for Wrigley Field and the Cubs started when I was seven and my dad brought me to my first Cubs game. My family had a thing called "Daddy Fridays" where each child chose an event that we wanted to go to with our dad that day or night. I chose a Cubs game, and so began my love affair with Wrigley Field.

I loved everything about it: the smell of the grass, the crack of the bat, the hot dogs, the cotton candy, the souvenir guy—and I especially loved the new words I learned from those around me. My dad eventually bought season tickets, and it was glorious. Every summer, you could find us sitting together at Wrigley, soaking up some rays and creating some memories in Section 25. Now at forty years old, I'm still sitting in those same seats with my dad.

When I met Billy, my husband, one of the first questions I asked him was whether he was a Cubs fan. I held my breath waiting for the answer because I knew he was the one. I also knew it would be close to impossible to go through life with a Sox fan. Thankfully, his answer was yes. We spent many of our first dates at Wrigley and still do. After two years, Billy proposed, Wrigley-style.

My sister and her husband are photographers who work with the Cubs when the team hosts Family Day at Wrigley for the players. Through this, they met a few people who could help assist my husband with the greatest proposal of all time.

It was a Tuesday night, and Billy and I had plans to go out to dinner. But first we were swinging by Wrigley to meet with someone about possibly

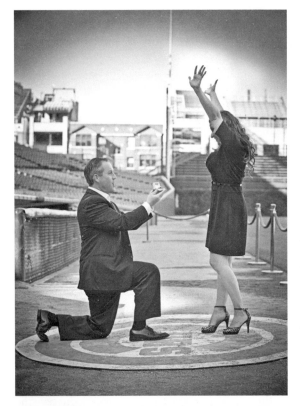

Left: Tina reacts to a surprise marriage proposal from Billy on the field at Wrigley in 2011. *Edenhurst Studio (www. edenhurststudio.com).*

Below: With a little help from a friend in security at Wrigley, Tina and Billy had a one-of-a-kind moment on the famous marquee. *Edenhurst Studio (www.edenhurststudio.com).*

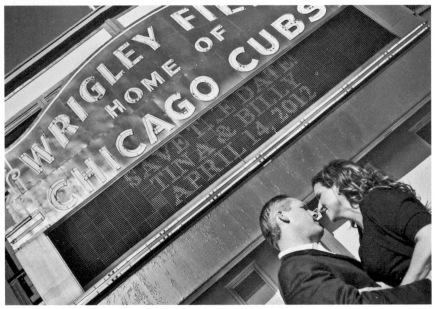

buying our own season tickets the following year. He wanted to see the seats in person. I didn't really think anything of it, as we had been talking about doing this for the past year or so. As we were walking around looking at different seats, I turned around to see my sister there with her camera and Billy down on one knee on the on-deck circle. I was in shock—the absolute happiest girl in the world.

To have brought together my love for Wrigley and my love for him into one big ball of wonderful was beyond words. Wrigley will always be something so special to me—it's where I grew up; where I got to know my dad as a parent and as a friend; where I spent numerous times with my sister, brother and friends; and, most importantly, where I started my journey with the love of my life. No place in the world can or will ever hold that kind of meaning, and it will always have its own special place in my heart.

Subsequently, my friend who is the head of security over at Wrigley allowed us about fifteen minutes one night to come back and do our "save the date" via Wrigley's marquee. I can't really explain to you how it felt to drive up to Wrigley to see our names up on the marquee along with the date we were getting married. It was like the proposal day all over again.

A DIFFERENT FAMILY TRADITION

TONY TAYLOR, PEANUT VENDOR

I've been out here selling peanuts and water for about six years. My uncle has been out here for close to forty years, so when I was a little kid, I used to come out here and watch him. I'm a schoolteacher, so once I got older, I thought it was nice way to make a little money on the side. During the summer, I come out here, interact with the people and make some money. If you're here every day, you establish a spot. We're all pretty friendly and communicate with each other. It's a nice job to do in the summer.

Wrigley Field is one of the best places to be at because there are a lot of different people from different cultures, and there's plenty of activity. It's just a great atmosphere. The big thing about peanuts is that everyone loves to eat them at a baseball game. And you need some water to drink while eating the peanuts, so I just put them together. It is cheaper on the outside, and we do give them more. We try to make our customers happy.

The people keep me coming back. I've got a lot of personal customers that come up and say hello. I have some customers who will walk all around the ballpark until they find me over here on Sheffield down the street from Addison. When St. Louis comes to town, it's always a big crowd. St. Louis fans aren't rowdy, and they buy a lot from me. I'm from the South Side, but I like the Cubs. I get to the games a lot because some of my personal customers will give me tickets. My kids and I will go in after I'm done selling. We'll go in there with a couple bags of peanuts and enjoy the game.

It's a great experience, especially if you're an out-of-towner. Wrigley is one of the biggest attractions in Chicago.

Left: Tony Taylor stands in the middle of Sheffield selling water and peanuts before a game. Street vendors have long been a part of Wrigleyville but now must be licensed by the City of Chicago. *Jenkins Imaging*.

Below: Sheffield Avenue sits quietly during the game but fills quickly after the final out. In past years, the Cubs have received permission to have Sheffield closed for street festivals during big series against rival teams, such as St. Louis and the White Sox. *Dan Campana photo*.

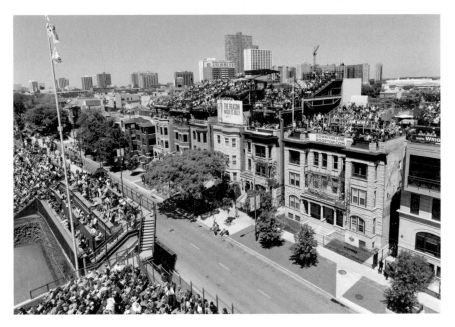

GROWING UP WITH THE CUBS

SUE JACOBI, FORMER WRIGLEYVILLE RESIDENT

Even though I now live in Kansas City, I grew up on Freemont and Addison, just three blocks from Wrigley. I was born there, so I grew up a Cubs fan. I grew up in the late '40s and early '50s on Freemont Street. We later lived in Lombard and still went to games as a family on both my side and my husband's side. We were all Cubs fans. My father-in-law was an official member of the Diehard Cubs Fan Club. The connections run deep. I'll be a Cubs fan until the day I die.

Where I lived, we could actually hear the ballgames—the announcers and everything—from our back porch. It was wonderful. Back before it was the "in" thing to do, we would walk down there as kids and stand outside the ballpark, listen to the game and wait for the players to come out after the games. The older I got, the more involved I got in watching them. You could sit out in the bleachers for next to nothing. When I started dating my husband, that's what we'd do. A lot of times, we'd just walk down and sit in the bleachers.

The best part of going for us when we were dating was going early to watch the players warm up. We'd see Ernie Banks, Glen Beckert, Ron Santo and Don Kessinger. We'd watch Milt Pappas on the mound dancing to "Zorba the Greek." I learned how to do a scorecard there; it was kinda like my first math class.

The area was just a typical North Side neighborhood, a family neighborhood. We grew up in an Italian household, which meant everybody came over for Sunday dinner. I can remember that if there were a ballgame

The bleacher lineup goes back to Wrigley's earliest days when seats in the famed outfield sections were not sold in advance, meaning lining up was the only way you had a chance at getting in for a particular game. *Jenkins Imaging.*

on Sunday, we would have to put the wooden horses out to save a parking space for my aunt and uncle. If they called and said they couldn't make it, then we could sell that parking space, which was kind of nice.

I'll always remember just being able to sit out on the back porch listening to the announcers and the sound of the crowd, whether it was a Cubs game or a Bears game. My dad had season tickets for the Bears and would go to the games regularly. It was usually a lot louder for the Bears games because the fans would scream a lot more.

FIRST IN LINE FOR OPENING DAY

STACEY JAMES, CUBS FAN FROM INDIANA

My husband, Dustin, and I got married as Cubs fans, dressed in Cubs gear at the courthouse. We came up to our first game about six years ago. I grew up in Florida and wasn't much of a baseball fan. When I first moved to Indiana, everyone was like, "What team do you go for?" I was drawn to the Cubs because of Wrigley and the atmosphere. You can't beat the nostalgia and excitement of all the people hanging around for games. I get it—they haven't won in a really long time, but winning isn't everything. We've sat everywhere, especially in the nosebleed sections, but never in the bleachers. You can tell it's a big deal for the bleachers with the way people line up. I've always wanted to sit in the bleachers, catch a fly ball and be where everyone wants to be. Up in the regular seats, you don't get the player interaction. That's why we got up at 4:30 in the morning to be the first here, so we can get in and choose our spots.

Dustin and Stacey James, Cubs fans from Indiana. *Jenkins Imaging.*

GETTING THE CHILLS AT WRIGLEY

MICHAEL WHITING, NEW CUBS FAN

A few things I love about Wrigley are the sights, the sounds and the smells. Every time I'm here, I get chills, even in the offseason. I went to a concert at the Cubby Bear, and just being near the park gave me chills. It's always exciting here. It's always great times with friends and family. Regardless of whether they win or lose, you know you're gonna have fun. One of the best times was just hanging out with my friends and my brother. We did the normal game stuff, and they won—getting to sing "Go, Cubs, Go" and wave our "W" flag was just the best time. It still brings a smile to my face. I haven't been a Cubs fan for very long, but a day at Wrigley is worth the highs and the lows, the winning and the losing. My heart was beating the first time I walked in, and I couldn't stop smiling. There's nothing better.

IT SOUNDED LIKE A STRIKE

KATHERINE S., SEASON TICKET HOLDER

I'm a transplanted Cubs fan. I grew up a Brooklyn fan and didn't come here until '62. In '69, it was too much like '51 in Brooklyn when the Whiz Kids knocked them out. After that, I couldn't watch for a while. I learned the game from Red Barber over the radio, and my mother taught me to keep score.

Although 1984 was the first year I really started coming, I did go to that 1979 game against the Phillies, the 23–22 game. We were way up in the Uecker seats, under the roof in the 500s way down the right-field line with my daughter, friends from Michigan and their kids. It was the mother's first game ever. I kept saying, "It's not usually like this."

Of course, 1984, was so exciting. There was the "Here's to you, men in Blue" and the t-shirts that said, "I'd trade my hubby for a Cubby." Every day was just a festival—it was so wonderful. The park has changed so much. Our view from Row 5 near the visitor's on-deck circle used to be really beautiful the way you'd go down from the scoreboard, but now it's all choppy.

I told Tom Ricketts that we don't need a Diamond Vision. The people who need replays will look on their smartphones. It's already changed so much. Now, with Rows A, B and C in front of us, you're not as close to the game and can't talk to the players anymore.

Back in 1985, we were here when Pete Rose was chasing the hit record. He had already tied the record before rain delayed the game. You wanted to be there for it. It got very dark, but no one left because only one person

had to get on base for Rose to bat again. He came up to bat in the ninth and was called out on strikes. He went back to the bench, and his son, who was traveling with the team, asked, "What was it?" Pete said, "Well, it sounded like a strike."

NO TIME TO SIT DOWN

JOHN RADTKE, CUBS FAN SINCE BIRTH

I grew up a Cubs fan on a dairy farm. My greatest memory of the Cubs as a kid doesn't include seeing them win or lose a single game. I was always in the car on the way home after the seventh inning because we had to milk the cows. We could never stay to the end of a game, so Vince Lloyd and Lou Boudreau became my best childhood friends.

My greatest game was Game 1 of the 1984 playoffs. I was a season ticket holder that year, and the hottest girl in town agreed to go with me to the first Cubs playoff game in decades. Our seats were in Row 9 behind the Cubs dugout. We stayed too long at the Cubby Bear and had to scramble to our seats just as Bobby Dernier led off the bottom of the first for the Cubs. A beer in each hand, we had just sat down when BOOM! Dernier unloads on a home run. Well, the beers went flying, the girl gave me a kiss and all was right with the world.

BAR SCENE GOOD; DRUNKS AND PARKING, NOT SO MUCH

JENNY VANSE, WRIGLEYVILLE RESIDENT

The bars are what really drew me to this area—that and the fact that there's so many people around. I'm a Cubs fan, so it's nice being able to hear the games. I don't go to many games; I'll usually just go to the bars to watch. It's occasionally loud, but it depends on how the Cubs are doing or who they are playing. During the Blackhawks riots after they won the Stanley Cup, it was wall to wall with people until two o'clock in the morning. There were people up and down the street screaming, and the fire trucks were blaring their horns.

Sometimes it's a nuisance here, like when you're coming home from work and there's drunken idiots going, "Hey, hey," and I'm like, "Get out of my way! I've been working twelve hours. I'm ready to

Parking, or lack thereof, remains an issue for fans attending games at Wrigley. While neighborhood parking is allowed for day games, permit parking restricts nighttime use of residential streets. To park in an official Wrigley lot outside the park, it'll cost a good amount any game of the year. *Jenkins Imaging.*

get home." The parking is the worst on game days. You have to time it right. There have been times when I've had to drive around for twenty minutes and end up five blocks away at Southport, which is not terrible, but it's a total inconvenience. When there's not a game, there's always parking, which is nice. The best times are during the game or at least an hour after. You cannot come before a game and expect to find a spot, even if the game starts at three and you're here at twelve, you're screwed—unless it's a night game and there's the parking restriction, which makes it a little better for residents. Seeing what happens while living here doesn't change my opinion of Cubs fans or the neighborhood.

A LIMITED VIEW OF HISTORY

JIM SONNENBERG, ATTENDED NHL'S 2009 WINTER CLASSIC

When I was thirty-four, I won a contest to get to play in a baseball game at Wrigley. On defense, I successfully fielded a grounder at third and gunned down the runner at first. I also flew out lazily to left field during my trip to the plate.

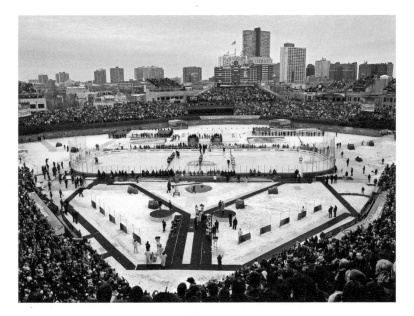

The NHL's Winter Classic brought hockey to Wrigley for the first time as the up-and-coming Chicago Blackhawks took on rival Detroit on New Year's Day 2009. *Bob Horsch photo (www.horschgallery.com).*

I'm a fan of both the Cubs and the Blackhawks, but I am a much bigger and more devoted hockey fan. I think it's just a better sport. For the 2009 Winter Classic between the Hawks and Red Wings, there were presale tickets available in a lottery for youth hockey families and organizations. Of course, they failed to mention the seats had limited views of the game action.

My eleven-year-old son and I had seats two rows behind home plate, which turned out to be a great vantage point when the teams came and went to the dugouts to get to the locker rooms. As the players came out and the pyrotechnics went off, it was pretty cool to be right there in it with forty thousand crazed hockey fans roaring their approval. The seats weren't so great for watching the game, but I felt it was worth all the hassle and aggravation of waiting and sitting in the cold to experience it at Wrigley instead watching it on TV.

REINTRODUCING HOCKEY TO CHICAGO

NICK ULIVIERI, ATTENDED NHL'S 2009 WINTER CLASSIC

My dad got tickets for the Winter Classic. I didn't ask how, I was just grateful I was able to go. The night before, New Year's Eve, I had a killer flu. I was supposed to work, but I called in because I could hardly move. The whole day I worried about whether or not I'd be able to make it to the game. I pounded water, Motrin and Advil and napped constantly in hopes that I'd feel good enough to go.

When I woke up the next morning, I still felt awful. But willpower is a funny thing. If you want something bad enough, you can overcome a lot—provided you take more DayQuil and Motrin than you probably should. I made it to Wrigley, and surreal is about the best word to describe the park that day. First of all, you're looking at a hockey rink on a baseball field—Wrigley, no less—in the winter. This is not a normal thing. Looking back on it now, to me, it was a public turning point for the Blackhawks organization. To see so many Hawks fans supporting their emerging team in a hallowed stadium on a national stage under idyllic winter-gray skies was the perfect storm to reintroduce Blackhawks hockey to Chicago.

CALLING A GAME, TELLING WRIGLEY'S STORY

CHIP CARAY, CUBS TV ANNOUNCER, 1998–2004

Like so many people who aren't from Chicago, until I worked at Wrigley Field, I really didn't understand how magical a place it really was. I grew up in St. Louis a huge Cardinals fan. My dad, my grandfather and I were all born in St. Louis. We kind of looked at the Cubs as this kind of alien life form. We didn't understand the culture. Wrigley Field and, to a lesser degree, Fenway Park are two of the last places in the world where you can go back and actually do what our sport is, and that's pass time.

I'll never forget the first time I walked in there. I was doing Orlando Magic basketball games, and we were in Chicago to play the Bulls in April and my grandfather left me a ticket. It was one of those gray, cold, cloudy April days. I walked in and saw the dead ivy and the people in the stands and thought, "Oh my God—it's 1930." So for people of my generation—people who are used to the circular ballparks and the Astroturf—to walk into Wrigley Field and see that for the very first time is really eye opening. And obviously to work there for seven years was amazing.

Was Wrigley Field the most beautiful ballpark from an architectural standpoint? No. Was it the cleanest? No. Was it the most comfortable in the winter or in the spring and fall? No. Was it very uncomfortable at times in the summer? Absolutely. Were the teams good when I was there? Not really. But there was always a story going on in and around the ballpark that went far beyond the game between white lines. The late, great Arne Harris, who directed the games for a so long for WGN, taught me something in the first couple weeks of doing this job. He said, "This is a TV studio, not a baseball

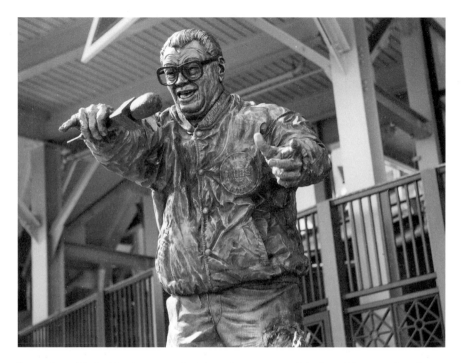

Located outside the bleacher gates, the Harry Caray statue originally resided near Gate D at Addison and Sheffield when it was unveiled on Opening Day 1999. Harry was moved in 2010. Fans have been known to place a beer can in his outstretched hand. *Jenkins Imaging.*

stadium. The Chicago Cubs are the longest daytime running soap opera in television." And he was right.

We had this story one day, getting beat 10–2, when some poor son of a gun pulled up beyond the left-field fence with a flat tire. Arne says, "Hey kid, take a look at this." The guy gets out of the car, sees a flat tire, puts his hands up and waves them like, "What do I do?" Pitch, a ball outside. Arne goes back to the guy, and he's in the trunk looking for the spare. Now Steve and I are kind of laughing and wondering where this is gonna go. There's no spare tire. The game's still going on: pitch outside, base hit, run scores, it's 3–2. We go back and see the guy with a jack, pumping up the car. You can see where this is going. He finally gets on the phone, gets a cab, comes back with a tire, puts it on and drives away. All of this took two whole innings. We didn't even have to comment on it, but we had so many e-mails and letters from people who enjoyed seeing the stories of life that evolved and revolved around that Wrigleyville neighborhood. That was one example of thousands of them that took place on a daily basis there.

For me, going to the park in 1998 was eye opening; I didn't have any idea what to expect. You can't imagine how hard it was Opening Day in 1998 to sit there. No one can replace Jack Brickhouse or Harry Caray. They are iconic voices of the sport in this town. My dad and I talked about it after my grandfather died, and after I'd been in the chair for a couple of years, he said, "Chip, there were really only two people who could have done the job you're doing: me—and I didn't want it—and you." It was always in my mind, at least at the start. It was my grandfather's team—it was his town, his station, his co-workers, his chair, his mic and his partner. And to this day, when I look up there, I think of Harry leaning out the window, not Mike Ditka, Ozzy Osbourne, Shania Twain or anybody else. One of the other difficult days came after three years of asking my dad to sing the song. He wouldn't do it; it reminded him too much of what he missed in his life. Finally, I got him to do it when the Braves were in town—I think it was in 2003 or 2004. That was really good closure for both of us, I think. I put my arms around him and had a tear in my eye, and I think he did, too.

The Cubs have the park and the fan interest worldwide—not just nationwide. The only ingredient that is missing is winning. If you believe in fate and you believe in the odds, their turn will come. When it comes, it's going to come big. I believe it would be the biggest celebration in the history of the sport. It would be well deserved for the long-suffering Cubs fans in Chicago. I hope it happens sooner rather than later.

A LIFETIME OF GAMES, JUST NOT THE WHOLE GAME

JOSEPH BRANDL, SAW FIRST CUBS GAME IN 1948

The first time I was in this park was 1948, but let me shock you a bit: I have not seen a full game here since 1948. Back then, it was $1.50 for the terrace seats behind home plate about halfway up. It was just beautiful; you could smell the lake. I was seven years old, and we were not real big on sports in my family, but the mother of a friend of mine brought me here.

Wrigley is one of the greatest parks in the world. It's the location, of course, as they haven't won a pennant in one hundred years, but everyone loves it. They come from all the surrounding states to be here. They don't care what the score is because they always have a grand time. This is a jewel of Chicago. When I hear they're going to build a hotel twenty stories high, I get furious. They better not ruin what this is. I've never seen a park so beautiful, especially looking east with those buildings. Nobody's got it. You watch these other parks on television—it's like they're in an open prairie or something.

CAMPING OUT FOR TICKETS

SHELLY DRAZBA, CUBS FAN WHO MOVED TO CHICAGO IN 1988

We've camped out and, more recently, picked up wristbands to buy tickets on the first day they went on sale because it's the start of baseball season. It feels like spring is here, and it'll soon be summer.

When my cousin and I camped out on Sheffield in around 1989 or 1990, it was cold, cold, cold. They started ticket sales in February back then. We were usually there at 2:00 a.m., not midnight like some, and we were about twenty or thirty back in the line. I grew up in Kansas City but have lived here since 1988. My family is from Chicago, and my grandmother was a longtime suffering Cubs fan. She used to listen to games while she ironed clothes. Even though I grew up a Royals fan, once I got to Chicago, I had to become a Cubs fan. Between my grandmother and my nephews, who live a few blocks away, being a Cubs fan is multigenerational. It's something we all have in common—we just love baseball. I have such a nice sense of family here.

FROM BULGARIA TO WRIGLEYVILLE

LILY BORANOVA, CHICAGO

Coming from Bulgaria in 2001, I didn't know about the Cubs. Now I'm a baseball fan, with my Cubbie decals on my car, because of my boyfriend of nine years and living down the street from Wrigley. Looking at the outfield wall, its like, "Oh my god, it's so close." You can reach it—you're like thirty seconds away.

I had never lived in the city before I immigrated here, and I wanted to live in Chicago. The suburbs are way too quiet, and my boyfriend and I couldn't afford downtown, so he said, "Let's go by Wrigley." We literally drove by, saw the for-rent sign, saw the apartment had good space and said, "This is our spot." It's perfect. Our friends love it when they come by and visit. They live in the suburbs, so they want to hit the bars. Where else can you go clubbing at two o'clock on a Sunday afternoon?

Everyone wants to know how it is down here. We're on an inside street north of the park, so we don't really see a lot of traffic here. You have the occasional neighborhood parties and people playing bags in the street, but it's not noisy. We open the windows and don't hear much of anything from outside. I always wanted the active lifestyle, to see people and socialize, so this atmosphere is perfect.

83

CUBS FAN CAMARADERIE

CAROL HENEGHAN, LIFELONG CUBS FAN

I've been a Cubs fan since I was born. I used to go to the bleachers when it was a dollar, even fifty cents, and just hang out. We'd take the bus and bring a sandwich, and we were set. There's so much camaraderie. You're always running into people you know at the game, and then you visit the bar afterward and dance. It's a great time, although I don't think I'd want to live in this neighborhood. Living in Chicago, I can just hop the bus to a game. I've been going to games with the same girlfriends I've had since we were four. We've been doing this forever. My husband goes to games, too. The bleachers used to be my favorite, but I can't handle that anymore, so now we sit in the Terrace Reserved infield. My favorite Cubs of all time are Kerry Wood and Ryan Dempster. When I was young, I loved Rick Monday. I loved Derrek Lee. You're always so heartbroken when they get rid of your favorite guy.

WRIGLEY AND FAMILY COMING TOGETHER AGAIN

MIKE DIMAIO, CUBS FAN FROM NORTH CAROLINA

My father was from Italy and was always big baseball fan. He's the one who would bring me here, and the first time I walked up those steps was as a seven-year-old in 1972 for a double-header against the Cardinals. We were here for like eight hours on a Sunday. Seeing all that green in the middle of this concrete and blacktop is still amazing to me. I've always told people I want my ashes scattered in center field someday.

I'm originally from Joliet, south of Chicago, but since I now live in North Carolina, Opening Day 2013 was my first time back to Wrigley since 1995. Before moving, I had my share of moments down here. I remember a game against the Expos when Pete Rose was playing for Montreal. He hit a line drive off Lee Smith's kneecap and it flew over to the shortstop, who doubled off the runner on first, and the Cubs won the game. I brought a buddy of mine down here the night the Cubs clinched the division against the Pirates. We drove down to party with all the revelers—there were people hanging off of balconies and climbing on the light stands drinking beer.

I've been to a few Opening Days, including in 1983, when it got rained out against the Expos. I think it was about twenty-five degrees. Coming back for Opening Day 2013 had extra meaning for me: it was the first time at Wrigley for my two daughters, Rachel and Grace, and the first game at any Major League park for my fiancée, Toni.

Wrigley is the best park in baseball, a truly awesome place, which makes it really special to share it with my kids. At sixteen and twelve, maybe they can

finally get a little of the Cubs-love gene going in them. To have them be part of Wrigley and the Cubs is really special to me. Hopefully they bring their kids someday and there are some World Series flags flying. I plan on being here when they win the World Series.

ENJOYED FIRST VISIT TO ENEMY TERRITORY

J.B. NELSON, BREWERS FAN

Despite living nearby in Milwaukee and being a baseball fan at heart, I've never been to Wrigley before. The tradition and the history behind any baseball field, especially Wrigley and the Cubs, is something I can appreciate. Some people look at Wrigley as a historical landmark. I've been to Fenway Park, and it's the same way with the history. Everything about Wrigley is so natural; nothing has been super updated, which makes it kind of cool. It's a neighborhood ballpark, which creates a fun scene you want to be a part of. It's cool to have the rooftop seats, where I sat for a game in 2013, that aren't inside the ballpark but still let you see the game. You don't get that anywhere else.

GLOVELESS APPRENTICE

MATTHEW GUSTIN, NEWBIE BALLHAWK

I came out to Wrigley in 2012 with no glove, just one I got off the street. The regulars were like, "You need to get a glove." So after the third game, I went and got a glove—and I was hooked. I got sixteen balls my first year.

When it's not packed and you can get a cheap ticket, I'll go inside to get more action. But on a windy day, it's perfect out here. If you get one off the bat without hitting anything, it's called a "pearl." That's what everyone wants. I mark every ball I get, like in 2012 when I got one the day the Cubs had 101 losses and they played the 102-loss Astros.

I've been a Cubs fan my whole life. My mom's a Cub fan, but my dad and brother are Sox fans, so it's like a family rivalry. My first game was probably in 1989. Mitch Williams was pitching against Dale Murphy, and I got a foul ball. I feel like I was a Ballhawk even back then. The next pitch, Dale Murphy hit a home run. Out here, I feel a little part of the ballpark. It's fun because it's free. If you don't have enough money to get into the game, you can still be part of it out here. Sometimes you can get lucky and trade a ball for a ticket.

RACING FOR A SPOT

RALPH KITRON, CUBS FAN FROM MICHIGAN

I've been coming to Opening Day for the last thirty years—maybe missed a couple because of new jobs. Opening Day is the best because of the excitement in the air and the fact that everybody's here for the same reason. So that's why we get up early and try to be first in line. A few times we made it, and a few times we were second or third. There's one guy who always beats me out here. You ask him how long he's been here, and he's says, "Oh, about half an hour." So, the next year, you leave a half hour earlier and he's still here first.

Normally, we'll listen to WGN Radio on the drive from St. Joseph, Michigan, because they'll talk about the game and the weather, and they're on scene to give you an idea of what's happening before you arrive. There's so much more excitement around the park on Opening Day. Maybe it's the magnet schedule. There's so much going on with the TV and radio stations and the neighborhood. It's just a great place to be. The best Opening Day was in 1994 when Tuffy Rhodes hit three home runs. Everyone threw their hats on the field. It took a good fifteen to twenty minutes for them to pick everything up.

My eighteen-year-old son caught a Derrek Lee home run while we were in the bleachers. That day, we were driving home—it's a good hour-and-a-half drive home—and he goes, "Well, I guess I can cross that off my bucket list." He almost walked the rest of the way home. Now whenever we come, the bleachers are where we sit. He brings his glove; he's ready for round two.

One of the great Wrigley Field traditions: waiting in line for the bleachers, where seats are not assigned. Get there early to pick your spot. *Jenkins Imaging.*

Being in the bleachers is kind of fun. We do batting practice, and once it's done, we make the circle around the whole ballpark. You can get out of the bleachers and go around, but you can't come in from the other sections. It's kind of a privilege to be able to walk around the rest of the park.

"WELCOMING" BACK GREG MADDUX

DEBRA STANTON, SELF-PROCLAIMED BLEACHER BUM

I'm a Bleacher Bum. I can't remember a time when I didn't come out to the bleachers. We do sixty games a year out in left field; right field sucks. It's just where we sat when I was younger, and it has a better view. Back in the day, Moises Alou was my buddy. You've got to be first in line for the bleachers so you can get in the front row. I'm a diehard Cubs fan, but when you hit the top of the ramp, it's like, "Here we go again," and I get that Cubs ulcer.

When Greg Maddux was with the Braves, he was in the outfield during batting practice. We're like, "Hey, Greg. Come on and throw us a ball. You're still a Cub." He ignored us and was rude to everybody but eventually got tired of listening to us bitch at him. Finally, he looked right at me as if he was going to throw it to me, and he did. I caught the ball and immediately threw it back and told him, "We don't need your fucking ball, Maddux." The whole bleachers went crazy. A few years later, Maddux came back to the Cubs. Before one game, he was in the outfield warming up and looked up at me. I asked, "You remember me?" And he goes, "I sure do."

THE OLD DAYS WITH GREAT NAMES

BUD KLEICH, SAW FIRST GAME AT WRIGLEY OVER EIGHTY YEARS AGO

My dad started taking me to games early on, so my first game would have been in about 1929 or 1930. When I first went there, the bleachers were on the ground, and tickets were probably twenty-five cents—real cheap. When they had double-headers, they used to have the field crowd. If the ball went into the crowd, it was ground-rule double.

On Father-Son Day, my dad would take me in for nothing, maybe with a couple other kids from the neighborhood, too. We used to sit in the bleachers, but later I liked the upper deck. When you get up there, you can see the whole field, and when the guys hit the ball, you can see where it's going. When you're in the box seats, you're close to the players, but you can't see the game as well.

Later, on my days off from the CTA, we'd go to games with my grandsons. I'd tell them to duck under the turnstiles—"We don't need to pay for you," I'd say to their father. We'd go up in the upper deck and follow the sun around the park to stay warm. Of course, there weren't a lot of fans up there in those days.

I remember seeing Hack Wilson, Kiki Cuyler, Riggs Stephenson, Charlie Grimm, Billy Herman and, my favorite pitcher, Clay Bryant. My dad liked Bud Tinning, so we would go back and forth about who was better. There was one game when the Cubs were losing in the ninth inning and the manager was going to bring in a pinch hitter. At this point, Riggs Stephenson was still a great hitter, but was getting old and so was sitting on the bench. The crowd started hollering, "We want Stephenson!" So they put him, he got a hit and the Cubs won the game.

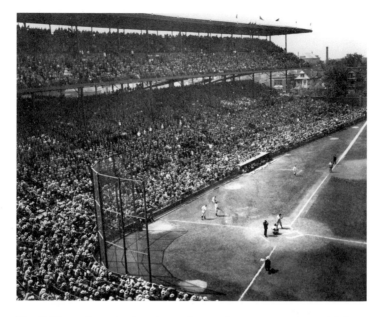

The field's configuration has changed many times as renovations added seats in the areas near the dugouts and behind home plate. *National Baseball Hall of Fame Library, Cooperstown, NY.*

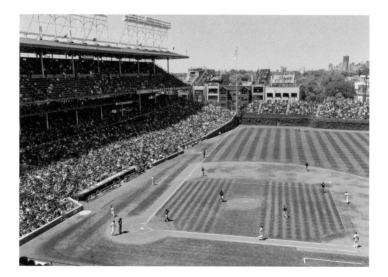

Fan attire and safety have changed as much as Wrigley's shape over the years. You'll find far fewer straw hats around the ballpark, but a larger screen behind home plate and Plexiglas shields are more prominent as seats have been moved closer to the action. *Dan Campana photo.*

FROM THE RIGHT-FIELD BLEACHERS TO COOPERSTOWN

PAUL JOHNSON, CUBS FAN/SPORTSWRITER

Growing up in the northern suburbs, my friend Dan Novacek and I were huge Cubs fans. In 1987, when we were eleven, new addition Andre Dawson became our favorite player. By 1996, Dawson was nearing the end of his career with the Marlins. After announcing he would retire at the end of the season, the Cubs held Andre Dawson Day at Wrigley Field on August 21, 1996. Immediately, Dan and I made plans to go to the game and get there early enough to sit in the front row in right field above the 368 sign. We wanted to get noticed, but since neither of us had any discernible artistic ability, I enlisted the help of my mother, Kathy, to make us a sign. It read simply: "Class is spelled Dawson. Thanks, Andre."

Before the game, we perched the sign in the basket that extends in front of the bleachers. Billy Williams, the Cubs' hitting coach at the time, saw it while exiting the batting cages and bowed to it just like Cubs fans did to Dawson in the six years he manned right field. We knew we had a winner with the sign.

When Dawson emerged from the right-field corner prior to the game to take a lap around the field, he pointed in the sign's direction and began to bow back to us. Everybody in right field flipped out. To us, we had shown the respect to our favorite player we intended to, and we went home satisfied.

Watching the game on tape later, we were excited by the numerous times the sign was shown during the broadcast. Another thrill came in the next day's paper, where you could see us as Dawson bowed to the bleachers.

The sign remained with me in the years, and apartments, that followed. Dan and I vowed, no matter where our lives would take us, that if and when

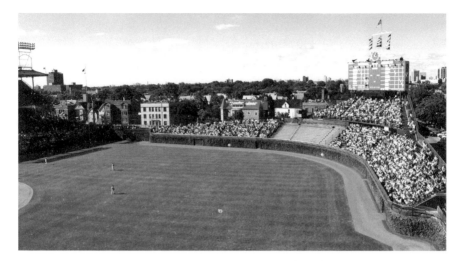

A mid-1990s view of the bleachers before shrubs were added to the hitter's backdrop area in centerfield. The indentations in the right- and left-field corners are known as the "wells." *National Baseball Hall of Fame Library, Cooperstown, NY.*

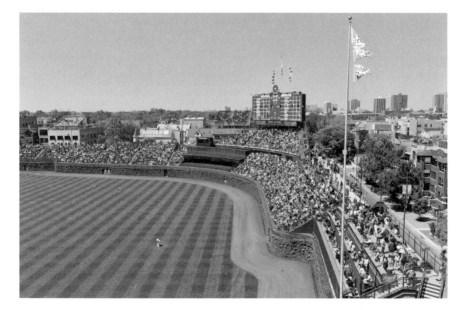

The top of the bleacher wall is peaked and has a basket extended from it, design decisions made in the 1960s to discourage fans from trying to get on to the field. More recently, a "patio" area was added to the right-field bleachers prior to the 2012 season. *Dan Campana photo.*

Dawson was ever enshrined in Cooperstown, we would make the trek to upstate New York with the sign in tow.

As the years ticked away and Dawson continued to wait his turn to be enshrined, I found out the picture of Dan and I in the Wrigley bleachers with the sign did make it into the museum. A college friend snapped a photo and emailed me to ask what I was doing in the Baseball Hall of Fame.

Finally, in 2010, after nine years of waiting on the ballot, Dawson got the call that he had been selected. Work and family responsibilities were put aside, because there was no question Dan and I were going for the induction ceremony. In Cooperstown, the sign was a huge hit yet again. MLB Network cameras found us throughout the weekend, and we followed through on a promise over a decade in the making.

In May 2012, I brought the sign to a book signing Dawson was doing. He was only supposed to autograph copies of the book, but I knew he'd recognize the sign if he saw it. Sure enough, he did, even asking, "Is that the original?"

He looked over the sign and autographed it, bringing an end to the journey we had begun so many years earlier in right field.

91

WHAT WILL MOM THINK?

ERIC RITTENHOUSE, PENSACOLA, FLORIDA
(FORMERLY OF DANA, ILLINOIS)

About thirty years ago, my wife, Pat, and I were going on a Long Point
Lions Club trip to Wrigley and decided to have Pat's mom, Penny, take
the train from the Detroit area to Chicago and meet us at the ballpark for her
first visit. As I waited outside for her cab, I got a little nervous that maybe I
had bragged on Wrigley too much and that it would be a letdown. As Mom,
Pat and I scurried through Wrigley's dark concrete bowels and underworld

Minus player
banners, the
main entrance
area near the
marquee looks
much like it
has for many
years. *Jenkins
Imaging.*

with water dripping everywhere, I saw this gloomy entrance through her eyes and got even more apprehensive.

But then we emerged out on the field, and it was incredible! The bright sunshine, the up-close action, the roar of the crowd was so vivid and exciting. I grinned from ear to ear, relieved that Wrigley was all I had said it was. The Cubbies won, our Lion's Club had smiles all around and Mom loved it. Now eighty-five years old, she still talks about our wonderful day at Wrigley Field.

READ ALL ABOUT IT

MATT JOZWIAK, MOUNT GREENWOOD, ILLINOIS

It was a close game. Unfortunately, the Cubs lost against Arizona in the playoffs in '07. We got swept—three and out. It was brutal. The best part was that we were watching out on Waveland. It was too expensive, and I was a little young, so we were on Waveland watching through a TV out at one of the apartments. There was a photographer taking pictures, and me and my buddy, Scott (Campbell), got on the front cover of the *Tribune*. He texted me in the morning and said, "Hey, we're on the front cover!" I don't buy the newspaper, so for the first time, I had to buy a paper because, unfortunately, the Cubs lost. The paper is still hanging in my room.

SOMETIMES THE ACTION HAPPENS ON THE OUTSIDE

CHAD ANDERSON, ROCKFORD, ILLINOIS

Following a midsummer afternoon spent in the bleachers watching a Cub loss to Houston in 2002, a couple friends and I met some attractive girls while leaving the stadium. We all thought it would be a good idea to find somewhere with air conditioning and cold drinks before we ended our day. After popping into a couple of the Wrigleyville staples, we came across the bar/dance club Hi-Tops on Sheffield, girls in tow.

The place was nearly deserted, save for the retro DJ and a few patrons who had the same idea. While we were on to our second round of drafts, a taxi pulled up outside of the bar. Our heads turned to see Moises Alou walk into the building. Moises had just been traded the previous offseason from Houston to Chicago, and within the hour, other taxis along with a team bus had dropped off what appeared to be a good portion of the Astros roster. All-Stars Jeff Bagwell, Billy Wagner and Craig Biggio stood out from what was steadily becoming a crowd.

As the bar slowly filled with local patrons, my friend Nick thought he would mingle with baseball royalty in his increasingly inebriated state. Nick started by chatting up Alou and offering to buy him a shot. Moises declined the offer saying, "No shot, no shot. Only beer." Nick obliged and bought the multimillionaire a couple bottles. Alou did not, however, turn down one of the young ladies that we arrived with on her suggestion that he teach her how to salsa dance. Once Moises began his smoldering lesson, we never saw the girls again.

Of course, the majority of the women who had filtered into the bar were all over these players. This fact may have contributed to Nick's dissatisfaction

with the way the night was playing out and his increasingly agitated—and still inebriated—state. Nick then struck up a conversation with Craig Biggio. Again the conversation began with Nick offering Biggio a drink and Biggio accepting. Nick, searching for an avenue for discussion, thought he'd bring up his frustration with both women and Cubs second baseman Mark Bellhorn's two errors that afternoon. Biggio wanted nothing to do with talking about that day's game.

I interjected again, stepping between my drunken friend and the future Hall of Famer, and apologized for my friend while Nick handed Biggio another beer. Biggio accepted and walked off to mingle with his teammates. As the bar continued to fill, a bouncer began roping off a VIP section for the players. We happened to be inside these lines. The bouncer came up to me and Nick and said, "This area is now reserved for these guys. You gotta go." Nick replied, "What are you talking about? We're with them." The bouncer expressed his disbelief, and Nick said, "Seriously. Biggio just bought me a beer." Coincidentally, at that moment, Biggio looked over at the commotion from across the bar. Nick raised his glass and pointed. Biggio raised his glass and pointed, as if to say, "Yeah, yeah, thanks for the beer asshole." The bouncer, however, interpreted Biggio's acknowledgement as a sign that we actually were friends, and we were allowed to spend the rest of the evening in the newly established VIP section.

A WRIGLEY FIELD TIME WARP

RICKY HEDRICK, ENID, OKLAHOMA

As a thirteen-year-old from Oklahoma, I went to my first Cubs game on July 31, 1997, when the Cubs were playing the Dodgers at Wrigley Field. I can still remember going through the neighborhoods and getting excited as I looked out the window for a glimpse of Wrigley. As we arrived, we realized there was no parking, so we parked in an elderly lady's garage a block away from Wrigley. We walked over to the players' parking lot and got some autographs and then walked around Wrigley visiting stores and such. While we did that, my dad, mom, brother and I didn't even realize what everyone was wearing or what we were walking into: it was '70s Night! The Cubs brought in KC and the Sunshine Band for a pre-game concert—even Harry Caray was in full disco gear! The Cubs lost 4–1 that night, but to this day, I don't think about that score. All I remember is seeing Wrigley, hearing Harry Caray sing "Take Me Out to the Ball Game," Disco Night and all that came with it.

FOUR FOR THE SHOW

CHRIS BARBER, GLAD HE KEPT HIS CUBS-YANKEES TICKETS

In spite of Game 6, Bartman, Moises Alou, Alex Gonzalez and the booted double play, 2003 was an awesome season. That year, I was working as a bartender at a restaurant in the Gold Coast neighborhood of Chicago. The lunches I worked were filled with regulars, construction guys, suits—you name it. One guy, a pretty decent tipper, asked me if I wanted four tickets to an upcoming Cubs game. As a lifelong Cubs fan, I never turned down free tickets. He told me they were for the Cubs-Yankees series at Wrigley. I was shocked. I asked how much he wanted to for them, and he said, "Nothing." He also told me they were four rows behind the Yankees dugout. I took them and called some of my closest friends and family members and told them to make sure they made themselves available for Saturday, June 7. This was the hottest ticket in town. I had offers of up to $4,000 for the tickets. I actually considered the offers, but as any true fan, I went to the game anyway. I brought along my brother, father and best friend. It was an incredible game—Cubs versus Yankees, and Roger Clemens going for win number 300 against Kerry Wood. Cubs first baseman Hee Seop Choi was knocked out early in the game in one of the most bizarre accidents I have ever seen on a baseball field.

Clemens and Wood went pitch for pitch most of the game, with Wood seeming to be the better of the two. Late in the game, Clemens was pulled for a reliever, and Choi's sub, Eric Karros, hit a three-run homer to put the Cubs ahead for good. When Karros hit that ball into the bleachers in left field, it was the loudest I had heard Wrigley in my entire life. It was

unbelievable, and the feeling was that this was the year. Sadly, we all know how it ended, but that Wrigley memory is something I will never forget. I'm glad I kept the tickets.

DON'T LEAVE WRIGLEY EARLY

DAN PLESAC, CUBS PITCHER, 1993-94/CUBS ANALYST, 2005-08

Wrigley holds a special place in my heart because I grew up in Gary, Indiana. The only baseball games you could watch on TV were the Cubs on WGN. To this day, I can still hear Jack Brickhouse say, "Santo, Kessinger, Beckert, Banks, infield third to first, Randy Hundley catching." There's so much of my childhood built around coming home from school and watching the final three or four innings of a Cubs game on WGN.

The first game I ever went to was in 1972. My dad took my two brothers and me to a Cubs-Cardinals game. My only memory of it is that we stayed until the seventh inning because we wanted to beat traffic. Right where we were sitting in the right center-field bleachers, Orlando Cepeda hit a home run literally as we were walking up the aisle. He hit it right where we were sitting.

I spent my first seven years in the American League with the Milwaukee Brewers, so I never had a chance to experience Wrigley Field as a player until 1993, when I signed as a free agent with the Cubs. This is before interleague play, so it wasn't unusual for players to go their whole careers in one league and never get a chance to see Wrigley. In the late '80s, early '90s, players were still hanging around with one team or in one league more than they do now. My first game as a player there on opening day 1993 was just incredible. It was so different seeing this old ballpark in a neighborhood in an era when you're so used to ballparks being built right off of freeways or intersections.

I probably speak for the majority of players when I say that there's no road trip like a three-day or four-day trip to Wrigley Field. It's a completely different animal as a visitor as opposed to a home player. As a visitor, you think the day games are great. Sunday getaway days are always a one o'clock start; you're gonna be at O'Hare and out of there early. As a home player, those day games wear on you. The newness of the day games wears off when you're on the other side.

The coolest thing in my two years was the first time Greg Maddux came back after he signed with the Braves. He made a start at Wrigley, and the fans threw back the first foul ball that went in the stands. They did the same with every other foul ball that was hit while he was pitching those first few innings. They were looking at Maddux as being a traitor for signing with the Braves. I was like, "Whoa, I thought this was grandmas and grandpas and little kids and the Friendly Confines." They were not too pleased Maddux left.

I loved going back there, although it was always an uneasy place for me pitch as a visitor. Because you only come in for three or six days a year, you get flooded with ticket requests from family and friends. You really wanted to perform well because you were playing back at home. I pitched in every park and an All-Star game, but it seemed like every game at Wrigley I just had the feeling that all the people who couldn't follow me in Milwaukee, Toronto or Arizona were going to watch this because it was on WGN. I always put a little extra pressure on myself because I didn't want to embarrass myself going back home.

BROTHERLY BONDING AT WRIGLEY

BILL PAYNE AND KEVIN REUTER, ADOPTED BROTHERS

Bill: This is my second trip in the last three years. The reason why I'm here is this guy right here. I just met this guy a little over a year ago. This is my brother. I'm adopted. I just found my mother a little more than a year and a half ago. So, we got together, and this is his first trip to Wrigley.

Kevin: I was born in Illinois, but I moved to Houston when I was two.

Bill: He just wanted to see a game here at Wrigley. He's always wanted to. I've been here a couple times. It's really just a great park to come to. It's a beautiful place to see a game.

Kevin: I grew up watching these guys (pointing to his Nolan Ryan Astros jersey) play the Cubs all the time on TV as a kid. Every time I'd watch a game, I'd think, "I want to go to that ballpark." That's the only ballpark that ever did that. Bill brought up the rooftops and said it didn't look closer on TV. And I was like, "Yes, absolutely. On, TV it seemed like it was right behind the bleachers—not across the street, right behind the bleachers."

Bill: You don't get that 3-D effect.

Kevin: We were walking down here, and I knew the park was down a certain road from what I had seen on TV from age six. I've got to be in the bleachers for my first time. Are you kidding? Where else would I sit?

Bill: I've been here five times. This will be my third Cardinals-Cubs game. Baseball is my number-one love; the Cardinals are my number two. Busch Stadium, old and new, they're alright, but you don't have the history that you do up here. You don't have the closeness that you do up here. You're sitting right on top the field. It's different than any place I've been.

TWO NIGHTS WITH "THE BOSS"

BRAD KING, SOUTH BEND, INDIANA

I'm a White Sox fan, born and raised on the South Side. To be honest, Wrigley doesn't hold a lot of appeal for me. I had been to one or two Cubs games as a kid. Since my dad's a diehard Sox fan, I remember this moment of sheer disappointment on his face when I told him I wanted to go to a Cubs game. Well, we've got another baseball team in Chicago, and I wanted to go see that one, too. He begrudgingly took us all.

Aside from being a Sox fan, I'm a huge Bruce Springsteen fan. My buddy and I both are. When they announced the first date for his shows at Wrigley, it was a given that we were going. Shortly thereafter, they added another show. Right away, I texted my buddy Tony. With Bruce, you're pretty much guaranteed to get a different show each night. We knew it would be worth it and that we wouldn't be seeing the same show both nights, and that's pretty much how it played out

The tour was called the Wrecking Ball, and my buddy and I were making jokes that maybe Bruce Springsteen would actually bring a wrecking ball to Wrigley Field. I wore a Sox hat both nights. I saw a lot of people in Cubs stuff and a lot of people in Sox stuff, but there were definitely a lot of rock shirts.

Bruce played almost three hours both nights, and there were a handful of repeats. The sound was pretty good from where we were sitting. The first night, we were sitting behind home plate. The second night, we were maybe ten rows up from the field along the third-base line. It was a lot better than when I saw the Stones at Comiskey in 2001. The general problem is—and

I'm sure all Cubs fans would agree—the hassle of getting there. But you're in a historic place. The rooftops were packed, and the streets were packed, too. Heading into the show, there were tons of people setting up camp in front of the apartments with their lawn chairs. I'm sure you could hear it well out there. If I couldn't have gotten tickets, I'm sure I would have done the same thing.

The first night was great because it was rumored that Eddie Vedder and/or Tom Morello were going to show up. And they both did. When Eddie walked out, the place just went insane. The first night, they played "Atlantic City" from Bruce's *Nebraska* album, and it was amazing. Tom Morello came out and played on two songs, which was just awesome.

The second night, everybody wondered if Eddie was going to come back. Before the show, as I was standing outside the Cubby Bear talking to my friend, I see this black SUV with tinted windows pull up by the stadium. Sure enough, Eddie Vedder gets out. Bruce introduced him, and the place went crazy. But the second night he performed "My Hometown," which is a great Springsteen song. It was a phenomenal moment for Eddie to sing "My Hometown" in his hometown. The other thing that happened that night was one of those magical concert moments you hear about. About three-fourths of the way through, it started to rain. Nobody moved. Bruce called an audible and played CCR's "Who'll Stop the Rain." It was one of those moments where you say to yourself, "This little moment right here makes it all worth it." It was a great moment that I will remember for a long time.

A MEETING WITH THE OWNER

JEREMY BEHLING, SPRINGFIELD, MISSOURI

On June 19, 2011, Father's Day, I got to watch the Cubbies play the Yankees at Wrigley Field. This was special because I'm a father and it also was my birthday. Before the first pitch, my brother, our friend and I struck up a conversation with a lady and her young son who had flown in from New York just to see the game at Wrigley Field. We talked about the first time taking the subway in Chicago and the differences between seeing a game at Wrigley Field and Yankees Stadium. Her son's birthday was a week before that. He was young. They were going back the next day. Their main thing was just to come and see the Cubs play the Yankees.

The conversation continued during the game until the middle of the third inning, when there was a brief pause in the action on the field. Tom Ricketts, the Cubs owner, was walking the upper 500 level of seating. He had noticed there were Yankees fans in front of us. He asked them how they liked the field and if they were having a good time. He had two or three baseballs in his hand. The mom said it was her son's birthday. Ricketts gave the young Yankee fan a ball for his birthday. He said he hoped we had fun, and then he left.

Although the Cubs went on to lose the game, the fact that Ricketts took a few minutes during the game to talk to us fans was pretty special.

CELEBRATING A CENTURY AT WRIGLEY

ONE-HUNDRED-YEAR-OLD CUB FAN FRANK MAREK (WITH DAUGHTER JAN)

Frank: We lived on Southport west of Wrigley and walked the railroad track to the ballpark. After the games, I remember the manager, or whoever he was, at the ballpark. He'd pick a few guys to pick up all the paper in the stands, and we'd get tickets for the game the next day. I liked the grandstand on the first-base side. I remember seeing Hack Wilson, Gabby Hartnett and Charlie Grimm. Gabby Hartnett was always gabbing to the batter. Grimm was a good first baseman. Hack Wilson—you couldn't beat him. When he'd strike out, his neck would get red he'd get so upset about it.

We did concrete work there on the box seats in the 1930s. They used to play football there before the Bears went to Soldier Field. We had to wait until football season was over, but we had to finish it before baseball season. I ran the mixer. We couldn't get the mixer in; they had to take the tank off to get it in that gate they have in right field. We had it right where home plate is. We had tarps and plywood and everything. There was no ready-mix in those days—we had to mix our own. You had gravel, sand and bags of cement. I started with the gravel pile and worked my way up to running the mixer. It was a big mixer. We poured concrete day in and day out. We started at one end after the football season and went to home plate. Then, next year, we did the other side.

Jan: What about in 1936 when they put the bleachers on Sheffield and your friend the fireman?

Frank: My friend the fireman was stationed on Waveland Avenue, so we went over to the park. There was a big line all the way down the street. So, my buddy and I were talking to the fireman. All of a sudden, the gates opened, and he goes, "Get in line." We were second or third in the big line. It was just fifty cents to get in the bleachers.

Jan: We didn't go to many games because we couldn't afford it, but he took us a few times. One time, there was a horse in the concourse. I was probably about eight, and living in the city, I'd never seen a horse before. I was so scared—it was so huge! Dad turned one hundred on June 22, 2013. We took him on his ninety-ninth birthday and on the tour a couple times…even had our picture taken right by the ivy—that was cool. For his 100th, we had like twenty-eight people wearing shirts with "100" on the back. He knew he was going to the park but didn't know about the birthday celebration. When we were on the field, the organist played "Happy Birthday." We took a picture on the field. He was in a wheelchair, and people kept wishing him Happy Birthday. He was like, "How'd they know it's my birthday?" I said, "It's on your shirt."

Frank: They had my name on the scoreboard. I was a little surprised, that's all. Nothing bothers me these days.

INDEX

ABOUT THE AUTHORS

Dan Campana is a freelance writer and communications consultant in the Chicago suburbs. He spent nine years as a newspaper reporter and editor at three suburban newspapers before venturing out on his own in 2010. He has a binder full of ticket stubs from Wrigley and can usually tell you if you have good seats after hearing a section number. Dan and his wife, Jen, have a son, Ryne, named for Dan's favorite Cub, Ryne Sandberg. Dan won the naming rights in a best-of-seven coin-flip showdown with Jen.

Rob Carroll is a writer and newspaper editor originally from central Illinois. His newspaper career began as a paper carrier when he was ten. By age nineteen, Rob was working in his first newspaper office. He has held various positions at newspapers throughout northern Illinois and the Chicago suburbs. In addition to his newspaper career, Rob also has spent time as a radio host in Rockford, where he resides with his dog, Benny, and a closet full of baseball cards and Cubs memorabilia.

Visit us at
www.historypress.net

···

This title is also available as an e-book